D0655544

THE GLASGOW BOYS
IN YOUR POCKET

THE
GLASGOW
BOYS
IN YOUR
POCKET

WILLIAM HARDIE

WAVERLEY
BOOKS

Published 2010 by Waverley Books,
144 Port Dundas Road, Glasgow, G4 0HZ,
Scotland

© 2010 Waverley Books

Cover image: Detail from *Girl with Poppies* by
Stuart Park, Dundee Art Galleries and Museums

ISBN 978 1 84934 026 7

Printed and bound in Poland

Contents

List of Illustrations 7

Acknowledgements 11

Preface 15

Abbreviations Used in This Book 17

Introduction 19

CHAPTER 1
Background 31

CHAPTER 2
Realism 1885–96 51

CHAPTER 3
Grez-sur-Loing 75

CHAPTER 4
Decoration 85

CHAPTER 5
Pastoral 95

CHAPTER 6
Japanese Interlude 105

CHAPTER 7
Kirkcubright Idyll 109

CHAPTER 8
A New Art 117

CHAPTER 9
Significant Others 145

CHAPTER 10
Postscript 161

APPENDICES
Biographies of the Glasgow Boys 167

Selected Bibliography 187

List of Illustrations

1 Alexander Greek Thomson,
 St Vincent Street Church 34

2 J. J. Burnet, *Grieve's, Sauchiehall Street* 35

3 Charles Rennie Mackintosh,
 Glasgow School of Art 37

4 Jean-Baptiste-Siméon Chardin,
 The Scullery Maid 39

5 Giorgione (da Castelfranco),
 The Adulteress Brought Before Christ 41

6 Adolphe Monticelli, *Autumn in
 the Field* 42

7 James McNeill Whistler, *Blue and Silver:
 Screen, with Old Battersea Bridge* 43

8 William McTaggart, *The Storm* 47

9 Sir James Guthrie, *The Highland
 Funeral* 56

10 Joseph Crawhall, *A Lincolnshire
 Pasture* 58

11 Sir James Guthrie, *A Hind's Daughter* 60

12	Edward Arthur Walton, *Bluette*	63
13	Joseph Crawhall, *The Race Course*	68
14	William York MacGregor, *Crail*	70
15	William York MacGregor, *The Vegetable Stall*	72
16	James Paterson, *Moniaive*	73
17	Sir John Lavery, *The Tennis Party*	77
18	William Kennedy, *The Deserter*	81
19	Thomas Millie Dow, *Sirens of the North*	83
20	Alexander Roche, *Good King Wenceslas*	86
21	Arthur Melville, *A Spanish Sunday: Going to the Bullfight*	91
22	George Henry, *A Galloway Landscape*	101
23	Edward Atkinson Hornel, *The Brook*	102
24	Edward Atkinson Hornel, *Japanese Dancing Girls*	106
25	James Stuart Park, *A Gypsy Maid*	115
26	David Gauld, *St Agnes*	119
27	Robert Burns, *Natura Naturans*	120

28 Charles Rennie Mackintosh,
 *The Tree of Personal Effort, The Sun of
 Indifference* 135

29 Margaret Macdonald, *La Mort
 Parfumée* 139

30 John Quinton Pringle, *Muslin Street,
 Bridgeton* 156

31 George Henry, *Barr, Ayrshire* 162

32 Samuel J. Peploe, *Spring, Comrie* 163

33 Thomas Annan, *Joseph Crawhall* 169

34 Thomas Annan, *Thomas Millie Dow* 170

35 Thomas Annan, *David Gauld* 171

36 Thomas Annan, *Sir James Guthrie* 172

37 Thomas Annan, *James Whitelaw
 Hamilton* 173

38 Thomas Annan, *George Henry* 174

39 Thomas Annan, *Edward Atkinson
 Hornel* 175

40 Thomas Annan, *William Kennedy* 176

41 Thomas Annan, *Sir John Lavery* 177

42 Thomas Annan, *James Pittendrigh
 Macgillivray* 178

43 Thomas Annan, *William York MacGregor* 179

44 Thomas Annan, *Arthur Melville* 180

45 Thomas Annan, *Thomas Corsan Morton* 181

46 Thomas Annan, *James Stuart Park* 182

47 Thomas Annan, *James Paterson* 183

48 Thomas Annan, *Alexander Roche* 184

49 Thomas Annan, *Robert Macaulay Stevenson* 185

50 Thomas Annan, *Edward Arthur Walton* 186

Acknowledgements

WARM THANKS ARE due to all at my publishers, Waverley Books, Glasgow.

Hic labor hoc opus est.

W. H.

The author and publishers are grateful to the private collectors who have allowed us to reproduce paintings in their collections and to the following organizations for allowing us to reproduce photographs and paintings held by them:

Douglas Annan for photographs by Thomas Annan of Joseph Crawhall, Thomas Millie Dow, David Gauld, Sir James Guthrie, James Whitelaw Hamilton, George Henry, Edward Atkinson Hornel, William Kennedy, Sir John Lavery, James Pittendrigh Macgillivray, William York MacGregor, Arthur Melville, Thomas Corsan Morton, James Stuart Park, James Paterson, Alexander Roche, Robert Macaulay Stevenson, and Edward Arthur Walton;

Culture and Sport Glasgow (Museums) for *The Adultress Brought Before Christ* by Giorgione [da Castelfranco] (Kelvingrove Art Gallery and Museum), *A Highland Funeral* by Sir James Guthrie (Kelvingrove Art Gallery and Museum), *The Race Course* by Joseph Crawhall (Kelvingrove Art Gallery and Museum), *Autumn in the Fields* by Adophe Monticelli (The Burrell Collection), *The Deserter* by William Kennedy (Kelvingrove Art Gallery and Museum), *A Galloway Landscape* by George Henry (Kelvingrove Art Gallery and Museum);

The Hunterian Museum and Art Gallery, University of Glasgow for *Blue and Silver: Screen, with Old Battersea Bridge* by James McNeill Whistler, *The Scullery Maid* by Jean-Baptiste-Siméon Chardin, *Moniaive* by James Paterson, *The Brook* by Edward Atkinson Hornel, *La Mort Parfumée* by Margaret Macdonald;

The National Gallery of Scotland, Edinburgh for *The Storm* by William McTaggart, *A Hind's Daughter* by Sir James Guthrie, *Bluette* by Edward Arthur Walton, *The Vegetable Stall* by William York MacGregor, *Saint Agnes* by David Gauld (Purchased with the aid of the Art Fund 1999) and *Barr, Ayrshire* by George Henry;

Dundee Art Galleries and Museums for *A Lincolnshire Pasture* by Joseph Crawhall, *Sirens of the North* by Thomas Millie Dow, and *Girl with Poppies* by James Stuart Park;

The Stirling Smith Art Gallery and Museum for *Crail* by William York MacGregor;

Aberdeen Art Gallery & Museums Collections for *The Tennis Party* by Sir John Lavery;

The Glasgow School of Art Archives and Collections for *The Tree of Personal Effort, The Sun of Indifference* by Charles Rennie Mackintosh;

The University of Dundee Museum Services for *A Spanish Sunday: Going to the Bullfight* by Arthur Melville;

Fife Council Libraries & Museums for *Spring, Comrie* by Samuel J. Peploe (Kirkcaldy Art Gallery);

Edinburgh City Art Centre: City of Edinburgh Museums and Galleries for *Muslin Street, Bridgeton* by John Quinton Pringle.

Preface

In 2010, 'THE GLASGOW BOYS' are the subject of a major exhibition at the Kelvingrove Art Gallery and Museum in Glasgow and later at the Royal Academy in London. My publishers suggested that a little book on the Glasgow School and some contemporaries would contribute to the celebrations.

Most of the content of this book has been drawn from my larger work, *Scottish Painting*, whose third edition will be published this summer.

The painters who have come to be known as the Glasgow Boys deserve to have their work enjoyed as widely as possible, and the hope of author and publishers is that the exhibition will bring their work to a new and larger audience.

I was involved with 'The Glasgow Boys' exhibitions at the Kelvingrove Art Gallery and Museum in 1968, the Fine Art Society in 1970, and the new Royal Glasgow Concert Hall in 1990. It is pleasant to revisit a theme that has preoccupied me for so long.

W.H. 2010

Abbreviations Used in this Book

AAG	Aberdeen Art Gallery
DAG	Dundee Art Gallery (The McManus)
ECAC	Edinburgh City Art Centre
FAS	Fine Art Society
GAC	Government Art Collection
GAG	Glasgow Galleries and Museums
GSA	Glasgow School of Art
HAG	Hunterian Art Gallery, Glasgow
NGS	National Galleries of Scotland
NPG	National Portrait Gallery
NTS	National Trust for Scotland
PAG	Paisley Museum and Art Galleries
RSA	Royal Scottish Academy
SNGMA	Scottish National Gallery of Modern Art
SNPG	Scottish National Portrait Gallery
TG	Tate Galleries
V&A	Victoria and Albert Museum
YCBA	Yale Center for British Art

The Glasgow Boys
and Some Contemporaries

Introduction

*I*N THE YEARS preceding the First World War, the prosperous city of Glasgow became recognized internationally as a centre for avant-garde movements in architecture, the decorative arts and painting, largely through the work of the artists associated with architect and designer Charles Rennie Mackintosh, whose genius took Germany and Europe by storm in the early years of the twentieth century. Mackintosh's path had been partly cleared, however, by the group of young Glasgow artists who collectively became known as the Glasgow School, but who preferred to call themselves 'the Boys'.

During the last two decades of the nineteenth century, they had broken through a number of professional and artistic barriers and attracted attention nationally and internationally, becoming recognized in Europe as representing a new kind of British painting. The *Oxford Dictionary of National Biography* states that the Boys first appeared as a coherent force in Scottish painting at the annual exhibition of the Glasgow Institute of the Fine Arts in 1885 (**article 64500**). In 1890 they held a highly

successful show of their work at Sir Coutts Lindsay's Grosvenor Gallery – the 'greenery-yallery Grosvenor Gallery' celebrated by Gilbert and Sullivan as a centre of avant-garde painting in London. It was this exhibition which first brought the similarities between their paintings to the attention of the wider world and caused them to be recognized as a 'Glasgow School'.

Their pictures were then taken to Munich, where they formed the centrepiece of the Secession Exhibition in the famous Glaspalast in 1890. Thus, when most of them were still in their twenties, began a period of international acclaim which saw the Boys exhibiting and selling paintings worldwide, in America, Australia and Canada as well as in Europe. The great Russian impresario Diaghilev, ever alive to new developments in the arts, borrowed several Glasgow School paintings for a show in St Petersburg in 1897. Until the Great War put a halt to All That, there were about a dozen Boys who formed the nucleus of the Glasgow School and about half as many again on the fringes of the movement (see the list that follows and the biographical appendix).

The Glasgow Boys and
artists associated with the group

Thomas Austen Brown (1859–1924)

Sir David Young Cameron (1865–1945)
James Elder Christie (1847–1914)
Joseph Crawhall (1861–1913)
Thomas Millie Dow (1848–1919)
David Gauld (1865–1936)
Sir James Guthrie (1859–1930)
James Whitelaw Hamilton (1860–1932)
George Henry (1858–1943)
Edward Atkinson Hornel (1864–1933)
William Kennedy (1859–1918)
Sir John Lavery (1856–1941)
James Pittendrigh Macgillivray (1856–1938)
William York MacGregor (1855–1923)
Harrington Mann (1864–1937)
Alexander Mann (1853–1908)
Arthur Melville (1855–1904)
Thomas Corsan Morton (1858–1928)
John Reid Murray (1861–1906)
James McLachlan Nairn (1859–1904)
James Stuart Park (1862–1933)
James Paterson (1854–1932)
Sir George Pirie (1864–1946)
Alexander Roche (1861–1921)
Harry Spence (1860–1928)
Robert Macaulay Stevenson (1854–1952)
Grosvenor Thomas (1856–1923)
Edward Arthur Walton (1860–1922)

The group was not a close-knit one and had no formalized structure or unity of aims, though they did briefly consider a more formal association, with William Kennedy as president, around 1887. Members did, however, share a number of ideas, opinions and principles which drew them together in a shifting pattern of friendships and allegiances. Foremost among these in the early days were admiration for the work of James McNeill Whistler and the naturalist paintings of Jules Bastien-Lepage, and a strong dislike of the tired genre and history painting of many Glasgow-based 'establishment' painters (whom the Boys dubbed 'Gluepots'). They were also ambitious and resented the stranglehold Edinburgh and the Royal Scottish Academy had over artistic life in Scotland. Prejudice against brash, industrial Glasgow was felt to be particularly strong.

The American born painter James Abbott McNeill Whistler (1834–1903) lived in London from 1859 (his mother joined him in 1863 in Lindsey Row, Chelsea), but his paintings were known as far north as Glasgow, and his ideas were widely discussed by anyone interested in art. He was admired and emulated by all the Boys, who were instrumental in the purchase of his portrait of Thomas Carlyle by Glasgow Corporation. He became something

of a hero to them as the very ideal of a modern painter. In particular, they were influenced by his rejection of incident in favour of more careful selection of a subject, by his interest in Japanese art, and by his admiration of the developments in French painting of the time. The early, realist phase of the Boys' work was most influenced by the ideas on social realism in art expressed in the work of French painter Jules Bastien-Lepage (1848–84), whose stark *plein-air* paintings of peasants and rural life attracted followers both at home and in Britain. Other sources were the Hague School, Courbet, and the Barbizon painters. The acceptability to them of simple domestic subjects accorded with Whistler's belief that the painter had a right to choose any subject that took his attention, whether it was considered significant by others or not. The Boys abhorred the overblown or sentimentalized subject-matter of the 'Gluepots'. But the French and Hague realists' use of a muted colour range, as with Whistler, appealed to them. The peasants and village folk the Boys chose to paint were not objects of pity, or prompts for moralising or sentimentality, but were painted with a matter-of-fact realism, as ordinary people going about the ordinary business of their uneventful day. It is perhaps worth noting that the everyday life of the urban

worker seems rarely to have been considered as a subject for their paintings, though W. Y. MacGregor did paint *A Joiner's Shop* in Argyle Street, Glasgow, in 1881 (private collection).

The key figures in the early days were James Guthrie and William York MacGregor, the 'father of the Glasgow School'. Both artists had an instinctive feel for the vigorous, masculine handling of paint with square brushes or a palette knife, and the use of powerful colour, which became the hallmarks of the Boys' style. The Boys would work in the studio in winter, and MacGregor's Glasgow studio became a meeting-place and a nursery of the new style. MacGregor, who was slightly older than the others, produced one of the earliest masterpieces by any of the group, *The Vegetable Stall* (1884), now in the National Gallery of Scotland.

The first, realist phase of the Boys' work culminates around 1885. This was also the year of Lavery's *The Tennis Party* (AAG), his master-piece representing the new realism and pain-terly techniques of the French strain introduced by those Boys who had studied in Paris – Lavery himself, Dow, Kennedy, James Paterson and Alexander Roche.

In summer, the artists worked *en plein air* at a series of favourite haunts in the Scottish

countryside from the Borders to the Trossachs, and Perthshire – Cockburnspath, Crowland, Brig o' Turk, Rosneath, Cambuskenneth – painting landscape with figures or animals. These poverty-stricken years, when a common purse was in use and the more successful or better-off artists would give their brothers-in-art a financial helping hand, saw the production of excitingly individual work by Crawhall, Melville, James Paterson and Walton. The integrity and forcefulness of Guthrie's work through the 1880s are especially impressive and give ample evidence of his importance in leading the Boys from their early, gritty realism – for example Guthrie's own *The Highland Funeral* (1882: Kelvingrove Art Gallery and Museum, Glasgow) – to the more decorative lyricism of their second phase exemplified by his *In the Orchard* (1885–86: McLellan Galleries, Glasgow).

In the late 1880s, a decorative tendency began to appear in the work of the School. In 1885 that strange artist E. A. Hornel had returned from his studies under Van Gogh's teacher Verlat, in Antwerp. Hornel's friendship with George Henry, commemorated by their joint work *The Star in the East* (1891: Kelvingrove Art Gallery and Museum), was the source of the second wave, decorative rather

than realist and concerned with two-dimensional composition and rich colour, often in a low key. These two artists, with Guthrie and Melville, are the chief exponents of this later development. From about 1850 foreign merchant ships had begun to visit Japan and after the Meiji restoration in 1868, Japan ended a long period of isolation and became open to imports from the West. In turn, many Japanese ukiyo-e prints and ceramics, followed in time by textiles and other arts, came to Europe and soon gained popularity, especially in France. It was Whistler who first brought Japanese prints to public attention in England, as he had acquired a fine collection while living in Paris, and it was Whistler's enthusiasm for Japanese art that influenced the Boys. However, Glasgow, with its many international trade links, traded in Japanese goods and there, as elsewhere in Europe, *Japonisme* caught the imagination of artists and public alike. The sudden influx of Japanese art at this time had an almost incalculable effect on Western art from then on and the passion for all things Japanese was widespread. Inspired by Whistler and funded by the influential Glasgow art dealer Alexander Reid and the collector William Burrell, Hornel and Henry spent eighteen months in Japan in 1894–95 in search of colourful subjects.

Melville, whose strong colours and bold technique influenced the younger painters in the group, had moved quickly from realism towards a more abstract representation of pure colour, light and movement. He had led an adventurous life that could have come from the pages of Robert Louis Stevenson – whom he knew – and travelled (on horseback) in Morocco, the Middle East and Spain, on epic journeys during which he was shot at, robbed, and abandoned naked by bandits in the desert. He first became associated with the Glasgow painters in 1882.

Stuart Park and Charles Rennie Mackintosh's friend David Gauld painted a few highly original decorative pictures in the later 1880s: Park's *A Gypsy Maid* (*c*.1890–95: DAG) and Gauld's *St Agnes* (1889: NGS) anticipate the spirit of the 1890s. Later, specialising in flowers (Park) or calves (Gauld), variations are slight in their highly commercial works, except that Park occasionally paints flowers other than roses, and Gauld uses a light palette for summer subjects and darkens his colours in winter.

Alongside the Glasgow Boys as practitioners of the 'Glasgow Style' were the 'Glasgow Girls', a term which first appears in William Buchanan's essay for the Scottish Arts Council exhibition of the Boys in 1968 – properly, to contemporaries,

members of the Glasgow Society of Lady Artists. The Girls' achievements were largely in the field of avant-garde design and decorative arts although there were painters among them (notably Bessie MacNicol, Stansmore Dean, Eleanor Allen Moore and Norah Neilson Gray). They included Margaret Macdonald, Frances, Macdonald, Jessie Newbery, Annie French, Ann Macbeth, Katherine Cameron and Jessie Marion King. Two of these (Margaret and Frances Macdonald), with Charles Rennie Mackintosh (husband of Margaret Macdonald and friend of David Gauld) and Herbert MacNair, made up a group known as 'The Four', whose work is discussed later. Mackintosh, neither a 'Boy' nor a 'Girl', but a revolutionary whose vision and influence touched both groups, remains the best known exponent of the Glasgow Style internationally.

The Glasgow Boys (and Girls) introduced a form of painting that combined Celtic and Japanese influences in a style which quickly found favour in Continental Europe. This merging of disparate cultures in Glasgow would have been impossible without that city's economic boom, which brought immense wealth to the many industrialists, businessmen and merchants who flourished there in the nineteenth and early twentieth century. The next

chapter describes the artistic patronage which established the reputations of the Glasgow Boys.

CHAPTER 1

Background

A REMARKABLE BURST OF creative vitality in the visual arts took place in Glasgow in the last two decades of the nineteenth century. Glasgow, 'the Second City of the Empire' (by 1890 just ahead of Melbourne in terms of rateable value), owed its recent rapid growth to shipbuilding, chemicals and cotton, the locomotive and heavy machinery industries, and (assisted by vast local reserves of coal) the production of iron, reaching at one stage a third of Great Britain's output. When steel took the place of iron, Glasgow's steel production was increased nearly twenty-fivefold in twenty years, to reach a million tons by 1900. Despite the bank failure of 1878 – which immediately gave a splendid excuse to provide employment by building the palatial City Chambers the following year – at the end of the century Glasgow rode on the crest of a wave of confidence and prosperity which was reflected in more widespread and gradually more discerning patronage.

The *'beautiful little city'* admired by Daniel Defoe on his visit in 1715, with its venerable Cathedral and ancient University, its merchant city thriving on the tobacco, sugar and cotton trades, prettily situated on the banks on the Clyde, had by the end of the nineteenth century become an international manufacturing and trading giant successfully selling its goods to the world. Its smoke-blackened stone tenements (recorded in the 1960s by the painter James Morrison, who found the later honey-coloured, restored Glasgow less appealing) enwrapped a city which had produced Adam Smith and Lord Kelvin as well as ships, chemicals, thread, sewing machines, and an 'A' list of pioneers in medicine. Glasgow's population in 1715 was just over 12,000; by 1890 it had jumped to around 800,000, making Glasgow the fourth largest city in Europe.

The photographer Thomas Annan (1829–87) captured the Boys for posterity, and it is thanks to him we know what they looked like (see Appendices). But Annan also made photographs of the Gorbals slums, the darker side which every Victorian city possessed but few on such a scale as Glasgow. In the noisome stone tenements (which we would have cherished today, but they were demolished long ago) life could be grim and art was of scant

concern. At the other end of the social scale at the turn of the century, William Davidson and Walter Blackie were successful publishers whose offices and printing works were in Glasgow, but whose villas, designed by the fashionable young architect Charles Rennie Mackintosh and furnished by him, were in Kilmacolm and Helensburgh. They inhabited another world, as did the wealthy industrialists and businessmen of the day. But it was their artistic patronage, using their 'new' money, that helped the local artists on their way. There was a network of influential local dealers to advise them on what to collect and to sell it to them, and many of them were keen on contemporary art, including Scottish art. Had they not erected fine buildings, bought pictures, and surrounded themselves with beautiful things there would have been no Glasgow School and no Glasgow School of Art.

Glasgow's strong local architectural tradition already bore the very personal impress of Alexander 'Greek' Thomson (1817–75), Charles Wilson (1810–63) and many others.

Among late-Victorian Glasgow's accomplished and original architects, the most eminent was Sir J. J. Burnet (1857–1938), whose Glasgow work dates from his return in 1878 from a period of training at the École des

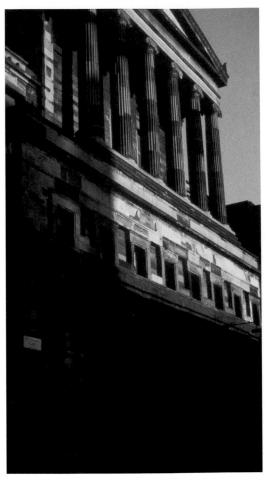

1. Alexander Greek Thomson,
St Vincent Street Church

Beaux-Arts in Paris. In a long series of buildings he developed an approach to architectural design which showed historicism applied with unpedantic inventiveness to contemporary urban requirements, from the skilful, witty addition to the Glasgow Stock Exchange (1849) in Venetian Gothic to the Sullivanesque McGeoch's warehouse (1905).

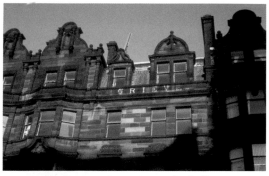

2. J. J. Burnet, *Grieve's Sauchiehall Street*

Burnet's Glasgow contemporaries included William Leiper (1839–1916), designer of a delicious Venetian Gothic extravaganza in polychrome brick and tile known as Templeton's Carpet Factory (1889), James Salmon II (1874–1924), and J. Gaff Gillespie (*d.* 1926), whose paths away from historicism led them to an Art Nouveau architecture.

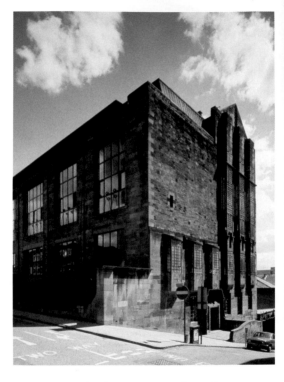

3. Charles Rennie Mackintosh,
Glasgow School of Art

Outside the old city, with its handsome new banks, insurance offices, churches and terraces, new communities sprang up in the pleasant green acres of Cathcart, Bridgeton and Pollokshields, along Great Western Road

and out to the Clyde resorts like Helensburgh, where the newly rich mansions provided a domestic counterpart to the public architecture of the Victorian city. Bare walls in many a grand drawing-rooms simply cried out for pictures.

The young Turks of Scottish painting collectively known as the 'Glasgow School' (but unconnected with the Glasgow School of Art) provide a slightly earlier background to the esoteric *fin de siècle* movement of Mackintosh and his friends.

The first mature works by these young 'Glasgow Boys' appeared in the middle 1880s but their creative impulse slackened after 1896. This aspect of the flourishing visual arts in Glasgow sprang from a happy combination of favourable economic conditions and a new consciousness on the part of the Glasgow public of the art of painting. The evolution of that taste requires a brief description here.

Through the decades, Glasgow had developed its own tradition in the appreciation of good pictures. The city's artistic independence may be said to date from the foundation in 1753 of the Foulis Academy within the University for the training of painters, sculptors, and engravers. This brave new enterprise was the brainchild of the brothers Robert and Andrew

Foulis, printers to the University. Robert, in McLaren Young's words 'an ardent if somewhat gullible collector', accumulated a collection of 450 mostly spurious 'Old Masters' for teaching purposes. The Academy produced the medallionist James Tassie (1735–99) and the genre painter David Allan, one of several students who visited the Glasgow alumnus Gavin Hamilton on the obligatory visit to Rome. It closed when Andrew Foulis died in 1775.

After more than thirty years, in 1808, the Hunterian Museum at the University was opened – the second public museum in Britain after the Ashmolean in Oxford – with its excellent examples of Rembrandt, Koninck, Chardin, Stubbs and Ramsay, and much else besides, left to the University by a collector of a very different stamp, the pioneer obstetrician, friend of Reynolds and connoisseur, William Hunter.

A variety of Glasgow exhibition societies had existed from the earlier nineteenth century, notably the Dilettante Society (begun in 1825) and the West of Scotland Academy, which lasted from 1841 to 1853. By the middle of the nineteenth century the taste of two widely travelled Glaswegians, the art dealer William Buchanan – a student at the University during the Foulis years

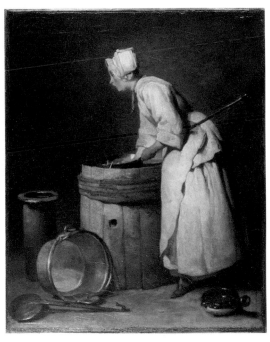

4. Jean-Siméon Chardin, *The Scullery Maid,*
© Hunterian Museum and Art Gallery,
University of Glasgow

– and the master coachbuilder and collector
Archibald McLellan, had made a considerable
impact on public collections in both Glasgow
and London. Buchanan was responsible for
bringing many important Old Master paint-
ings to Britain, including Titian's *Bacchus and*

Ariadne and *The Toilet of Venus* by Velazquez, both now in the National Gallery. He may have acted as adviser to Archibald McLellan, who in 1853 left to the City of Glasgow an art gallery and a large collection of paintings including Giorgione's *The Adultress Brought Before Christ* (GAG). The landscape background of this famous picture seems to have influenced the early Glasgow School painters.

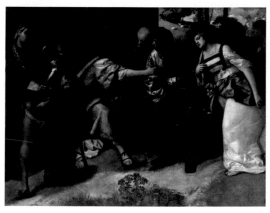

5. Giorgione (da Castelfranco),
The Adulteress Brought Before Christ,
© Culture and Sport Glasgow (Museums)

In the 1860s there were two foundations that had an immediate influence on the development of the Glasgow School of painters – the Fine Art Institute (later the Royal Glasgow Institute

of the Fine Arts) in 1861, and the Glasgow Art Club in 1867.

The early exhibitions of the Fine Art Institute were held in the McLellan Galleries at 254–290 Sauchiehall Street. There is no clearer indication of the Glasgow public's interest in art at the time than the Institute's decision in 1879 to provide itself with sumptuous new premises at 171 Sauchiehall Street, merely a year after the crash of the City of Glasgow Bank had brought financial ruin to many of its shareholders and had caused a short-term cash crisis in the city.

This new Fine Art Institute, designed by Sir J. J. Burnet, had an elaborate sculptured frieze by John Mossman (1817–90), who was the teacher of Pittendrigh Macgillivray (1856–1938), the only sculptor to be associated with the Glasgow group. During the 1880s Macgillivray was closely associated with the Boys, and he played a leading role in the founding and editing of their journal, the *Scottish Art Review*.

On at least one commission – the funerary monument to Alexander McCall (1888: Glasgow Necropolis) – he collaborated with the architect Charles Rennie Mackintosh. Several pieces of his sculpture were shown at the 1971 Scottish Arts Council exhibition of the work of the Boys.

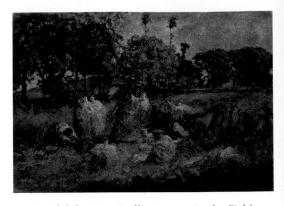

6. Adolphe Monticelli, *Autumn in the Field,*
© Culture and Sport Glasgow (Museums)

The importance of the annual exhibitions held at the Glasgow Institute in the 1870s and 1880s was twofold. Artists living in Glasgow and the west of Scotland had for some time been tacitly barred from membership of Royal Society of Arts in Edinburgh.

The Institute provided for the products of artists living in Glasgow and the west of Scotland but the Loan Sections of these exhibitions began to reflect the taste of the more advanced collectors in Scotland for the works of the Barbizon School, Bastien-Lepage, and the Hague School. In the middle 1880s, works by Monticelli, Whistler, Rossetti, Burne-Jones and William Stott of Oldham began to appear.

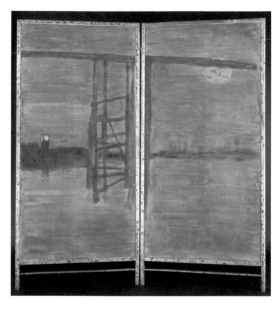

7. James McNeill Whistler, *Blue and Silver: Screen, with Old Battersea Bridge,* © Hunterian Museum and Art Gallery, University of Glasgow

The Glasgow Art Club's exhibitions were less ambitious, having more the role of a market for the work of members of the Club. This was a necessary economic function, but it may be supposed that much of whatever lustre the Club possessed must have departed when three of its most distinguished members, Daniel Macnee and the landscapists David

Murray and Alfred East (all later knighted), left Glasgow for the bright lights of Edinburgh and London in 1876 and 1883.

In the early 1880s, therefore, the situation in Glasgow was such as to provoke in any young artist of talent and originality a sense of frustration at the prospect of long years of exclusion from the RSA establishment in Edinburgh, and an awareness of the superiority of the works of the foreign schools which were represented in the annual exhibitions of the Glasgow Institute.

Added to that was a feeling of disgust at the frank commercialism and the sentimental, ancedotal approach of the so-called 'Gluepots', who formed the majority of the membership of the Glasgow Art Club and whose use of heavy brown megilp varnish earned them that unflattering but apt nickname.

Macaulay Stevenson is a good source of information on this period. In his *Notes* written in 1891 on the Glasgow School, he estimated that there were about 150 professional artists working in Glasgow.

He pointed out that the Glasgow School artists *'did not seek the name and were but a dozen or so in all'* (a total he later increased to twenty-three in a letter to T. J. Honeyman in 1941). His notes trenchantly

underscore the views of the younger generation of Glasgow painters who were still struggling to make their way against public apathy or official benightedness.

Stevenson castigates the preference of the selection committee of the RSA for anecdotal painting, commenting:

'Alas poor Edinburgh! It was left to live on traditions. The life of the community is fettered by the effete conventions of a faded gentility and eaten into by the dry rot of an exclusive and self-sufficing "culture".'

Praising the display of modern French and Dutch masterpieces assembled by T. Hamilton Bruce for the Loan Section of the Edinburgh International Exhibition of 1886, Stevenson describes the Barbizon School as

'the greatest event that had occurred in art since Rembrandt.'

He then emphasizes the important role of the Glasgow Institute in bringing in annually to Scotland excellent examples of the work of the Barbizon and the Hague School artists and of Bastien-Lepage. He praises the fact

that these borrowed works were often hung in juxtaposition with works by local young artists and emphasizes that the Institute was *'the real school – not Paris'.* Stevenson, ever the controversialist, actually goes out of his way to dismiss suggestions of French influence:

'Even in W. E. Henley's brilliant paper The National Observer *in which appear the most capable art critiques in the country the whole group are to this day blunderingly described as the Scoto-French School – much to the amusement of the men themselves.'*

Stevenson, who was anti-Establishment, anti-Church, and anti-'Gluepot', approved at least of some of the foreign artists shown at the Glasgow Institute. And he worshipped Whistler. But it is rather strange that he makes no reference, as far as I know, to William McTaggart (1835–1910), the sea and land-scape painter whose contemporaries during student days in Edinburgh, John Pettie and Sir William Quiller Orchardson, worked in London and enjoyed the esteem of the new generation there. McTaggart was, after all, the greatest painter of his generation in Scotland. Perhaps he was too Edinburgh. His work must

have been known to Guthrie and Walton, and the paintings by Guthrie done in Crowland show some influence of McTaggart's sunlit painting, though the Boys in general favoured a more tonal approach, working *en plein air* in, ideally, a consistent light.

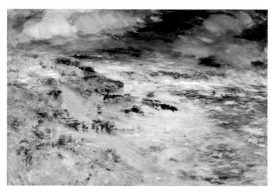

8. William McTaggart, *The Storm*,
National Gallery of Scotland

Another key collector of foreign painting was Glasgow dealer Craibe Angus (1830–99). As early as 1874, Angus had opened a gallery in Glasgow, and he seems to have introduced paintings by Corot, Diaz, Rousseau, Bosboom, the brothers Maris, Israels and Anton Mauve to Glasgow, although unfortunately he was unsuccessful in selling the *The Sower* by the

great J. F. Millet (1850: Museum of Fine Arts, Boston) to a Glasgow client, despite bringing it briefly to the city at an unknown date. One of his principal Glasgow customers was the collector James Donald. Angus's son-in-law, the Dutch dealer Van Wisselingh, handled Courbet, and the family connection is a likely factor in the early arrival of paintings by the French Realist in Glasgow.

Angus, furthermore, acted as the Glasgow agent of the Aberdeen-born dealer Daniel Cottier (1839–91), who had galleries in London and New York and was the first to introduce paintings by Monticelli into Scotland. The Cottier Sale in Paris included no fewer than twenty-five paintings by Monticelli – a total approached by the sixteen in W. A. Coats's collection (which also contained thirteen by Corot). John Reid of Glasgow had seven Corots and eleven pictures by Josef Israels.

Among other important collectors at this period were T. Hamilton Bruce in Edinburgh (noted above in connection with the French and Dutch Loan Section of the Edinburgh International Exhibition of 1886) and A. J. Kirkpatrick in Glasgow, whose collection included works by the Hague and Barbizon painters, and Courbet. As we have seen, the Aberdeen collector J. Forbes White had been to

Paris in 1873 and had bought the large Corot *Souvenir d'Italie* (1873: GAG) in the same year. His collection also included a Courbet and works by the Dutch Impressionists, some of whom he knew personally.

Realism 1885–96

THE MOST VITAL period of the Glasgow School lasted from approximately 1885 until 1896. This period encompasses early groupings based on close friendships and artistic congeniality which formed, initially as separate entities, around Sir James Guthrie (who was mainly self-taught), W. Y. MacGregor (who trained at the Slade in London), and Sir John Lavery (who studied at Julian's in Paris). It includes the eighteen monthly issues of the *Scottish Art Review* (1888–89), the organ of the School, and ends shortly after the return of E. A. Hornel (who had trained in Antwerp) and the Glasgow-trained George Henry from their visit to Japan in 1893–94.

Initially, the work produced during this period stemmed from a rejection of the academic finish and sentimental narrative style which were the stock-in-trade of the majority of contemporary painters, together with a whole-hearted adoption of realism in subject and style. The main sources of this early realism were

Bastien-Lepage, the Hague School, Courbet, and the Barbizon painters.

In the late 1880s, a decorative tendency began to appear in the work of the School. This later development promised well, and a number of works of real originality were produced, notably by Arthur Melville, George Henry, E. A. Hornel, Stuart Park, Joseph Crawhall, Alexander Roche and W. Y. MacGregor. A highly successful exhibition at the Grosvenor Gallery introduced this Scottish phenomenon to a London audience and led to exposure at the Munich Secession and large sales throughout Europe, North America and elsewhere. However, the vitality of this later impulse seems to have evaporated shortly after 1895, when commercial and other considerations began to tame the vigour of most of these artists. The Glasgow School is thus almost exactly contemporary with the New English Art Club, which several of the Glasgow painters joined at its foundation in 1886 and which acted as a rallying point for young artists in rebellion against academic standards and anecdotal painting.

The Glasgow School's origins may be traced to 1878 and two friendships.

In that year W. Y. MacGregor (1855–1923), 'the father of the Glasgow School', and James Paterson (1854–1932) were painting together

at St Andrews. Also in 1878 Sir James Guthrie (1859–1930) and Edward Arthur Walton (1860–1922) met and became friends. By then Walton's brother Richard had married one of the sisters of Joseph Crawhall (1861–1913). This relationship resulted in Crawhall's first visit to Scotland in the summer of 1879. He painted with Guthrie and Walton at Rosneath in Garelochside, some twenty miles from Glasgow. Very few paintings from before 1880 by these five artists can now be traced, but the opinion of Sir James Caw, art historian and museum director, based on acquaintance with many of the Glasgow painters, that MacGregor and Paterson were the first exponents of the early realism of the School, must carry some weight. In the autumn of 1879, Guthrie and his mother were living in London, where Crawhall stayed with them. At this time Guthrie was receiving advice and encouragement from the Edinburgh-trained painters William Quiller Orchardson and John Pettie. At the latter's suggestion Guthrie stayed in Britain instead of going to France to train as he had originally intended. Caw tells us that Guthrie *always spoke with respect of Pettie and Orchardson*.

In 1880 Guthrie and Crawhall exhibited a joint work, *Bolted*, in an exhibition in Newcastle, and in the summer of that year, were painting

with E. A. Walton in the open air at Brig o' Turk in Perthshire, where in the following year they were joined by George Henry (1858–1943) and others. The slightly older Edinburgh artist Robert McGregor (1847–1922) was then also painting in the village.

The winter life classes in W. Y. MacGregor's Glasgow studio seem to have been started in 1881. By all accounts these were of great importance in the development of the Glasgow style. They encouraged artists to reject anecdotal subjects and to use a freer technique and bolder colour. By 1885 these winter classes were attended by James Paterson, T. Corsan Morton, Alexander Roche, John Lavery, E. A. Hornel and Thomas Millie Dow. They were also attended by Henry, Walton, and Crawhall. In these years Henry, Walton and Crawhall also painted with Guthrie (who never attended the classes in MacGregor's studio) at the newly discovered Cockburnspath in Berwickshire, where Arthur Melville (1855–1904) was also working in 1883–84. A rare photograph (in the Walton family collection) from this period shows Walton and his brother, the designer George Walton, with Guthrie, Crawhall and Whitelaw Hamilton at Cockburnspath and conveys the *joie de vivre* of the young artists; another slightly later photograph from the

same collection records the little bohemia of Walton's studio at Cambuskenneth near Stirling in 1888. The mantel is decorated with four Japanese colour prints and with what appears to be a palm fan or perhaps an easel decorated in Whistler fashion with a Japanese motif.

The sense of a youth movement, strong in these rare records, is further conveyed in Macaulay Stevenson's *Notes*, in a passage written *c.*1892:

'So great were the difficulties of some in getting the bare means of subsistence and of carrying on their work that one or two of the largest earners among them seriously proposed having a common purse, as the only means of meeting the case … the common purse has practically existed during all those years and exists still.'

Following a difficult start in life (he was orphaned at the age of three when his father drowned when the *Pomona* sank *en route* for New York and, overcome with grief, his mother died three months later), Lavery, aged seventeen, was apprenticed to a photographer in Glasgow and resolved to become a painter. He paid his own fees at the Haldane Academy of Art in Glasgow, studied in Paris, and went on to enjoy great wealth and respectability as a leading

portrait painter of his day, first in Britain where
he painted, among many other society figures,
the royal family (1911: NPG) and Winston
Churchill (1915: Hugh Lane Municipal Art
Gallery, Dublin) and after 1935 in the USA,
where he painted Shirley Temple and other
Hollywood stars. By 1892 Lavery was certainly
among those artists who had become successful
(forgeries of his work were in early circulation).
Perhaps he helped his poorer brethren, but we
do not know. One would like to think he did.

These groupings of artists still in their early
twenties had a stimulating effect on their devel-
opment, and several works dating from this first
phase of the Glasgow School until about 1885
show real accomplishment and originality.
Visiting Guthrie at Cockburnspath in 1884, Sir
James Caw formed the impression that at that
stage Guthrie was the mainstay of the group –
an impression confirmed by the rapid progress
of his style in the space of a few short years,
and independently corroborated by the fact
that two works by Guthrie acted as the magnet
which drew the charismatic figure of Arthur
Melville to the Glasgow group and persuaded
the brilliant John Lavery to return to Glasgow
instead of London at the end of his period of
study in Paris.

In 1882, at the age of twenty-three, Guthrie

painted *The Highland Funeral* (Kelvingrove Art Gallery and Museum), inspired by a funeral he had witnessed at Brig o' Turk. This ambitious work, measuring 129 cm × 193 cm, is a vigorous if somewhat clumsy piece of realism that probably owes its bold handling and possibly its subject to Gustave Courbet, and it marks a complete break from the influence Pettie had on Guthrie's early work.

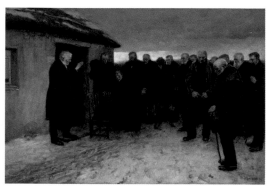

9. Sir James Guthrie, *The Highland Funeral*, © Culture and Sport Glasgow (Museums)

On seeing this painting exhibited at the Glasgow Institute, Arthur Melville, himself at that date working along similar realist lines, asked for an introduction to the artist. Guthrie seems (according to the Stevenson *Notes*) to have visited Paris for a few days in 1880, and to have

made another short visit in 1882. It is therefore entirely possible that he would have been aware of the *Burial at Ornans* (finally accepted by the Louvre in March of 1883 and immediately the object of renewed controversy) and perhaps also further works by Jules Bastien-Lepage, who is usually mentioned in connection with Guthrie's next ambitious work, *To Pastures New* (1883: AAG). Guthrie had painted *A Hind's Daughter* (1883: NGS) while living in Cockburnspath, in Berwickshire, but it was in Helensburgh, to the west of Glasgow, that he completed his much admired *To Pastures New* and his subsequent pastel images of middle-class suburban life.

This large picture represents a considerable advance and shows great assurance in handling and colour, although it should be added that *The Highland Funeral* had originally been painted in a higher key and had only been darkened at Walton's suggestion. *To Pastures New* still appears notably light in key, and a certain element of the 'Kodak' realism of Bastien-Lepage is tempered by the chromatic delicacy of the work, which is tenderly coloured in harmonies of white quite unlike the predominant browns and greys of the French painter, and at the same time has a considerable richness of surface.

To Pastures New was the work that persuaded

Lavery to return to Glasgow. It more than holds its own with another important Glasgow School painting of the same date, produced in all probability at Crowland, *A Lincolnshire Pasture* (1882–83: DAG) by Joseph Crawhall. This was possibly painted in Guthrie's company, and is dependent to some extent on Jacob Maris but already reveals the peculiarly vivid draughtsmanship which makes Crawhall unique among animal-painters of any period.

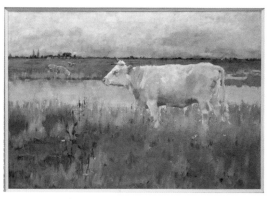

10. Joseph Crawhall, *A Lincolnshire Pasture,*
Dundee Art Galleries and Museums

Two other notable pictures by Guthrie in 1883 indicate an effervescent talent: *Hard at It* (1883: GAG) and *A Hind's Daughter* (1883: NGS). *Hard at It,* painted in the same harmony of pale blue and white as *To Pastures New,* shows

a fluidity of handling worthy of early Peploe. While *A Hind's Daughter* adds a powerful but controlled impasto (laid on with the palette knife) to a sympathetically rendered theme of country-style young girlhood, akin in feeling to the work of Robert McGregor, it is also more general and less anecdotal.

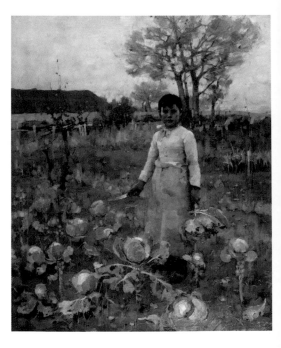

11. Sir James Guthrie, *A Hind's Daughter*, National Gallery of Scotland

In its powerful handling, rich tonality and sense of childhood at one with nature, this work anticipated an important aspect of the early Glasgow School (particularly what might be described as its Kirkcudbright offshoot, the work of Henry and Hornel and to some extent Bessie MacNicol).

Schoolmates (1884: Museum of Fine Arts, Ghent) shows Guthrie in what may seem to be a Bastien-Lepage vein, but actually it again bears more resemblance to such earlier works of Robert McGregor as *The Knife Grinder* (1878), and *Great Expectations* (exhibited 1880), both in Dundee's Art Gallery, the McManus. With the heads much more minutely modelled than any other area of the composition, the finish of *Schoolmates* is treated discrepantly, as is another childhood subject in *In the Orchard* of 1885, although here the trees, foliage, and grass are painted with a breadth of expression which produces a generalized and decorative effect.

A similar tendency appears in E. A. Walton's rare early figure subjects. The impasted colour of Walton's portrait of *Joseph Crawhall* (1884: SNPG) which, were it not dated, seems ten years or more ahead of its time, is succeeded in Walton's most important work in the following year, the wistful *The Daydream* (NGS), by

a subdued tonality and inconsistencies of handling as between the flesh tones and the draperies and landscape.

It is as if Guthrie and Walton had taken to heart Ruskin's stricture on John Phillip's treatment of detail: *'It is indeed quite right to elaborate detail but not the ignoblest details first.'* Realism posed a problem for these painters in their treatment of the human figure in landscape, and their eventual specializations in portraiture and landscape evaded the problem by dealing with its parts. However, Guthrie, made a successful attempt to solve it in the years 1888–92 with two series of pastels of domestic subjects, of which *Causerie* (1892: HAG) is a fine example.

Indeed, Guthrie's pastels with their subtle, intimist approach and delicate evocations of light – qualities which he seems only on one occasion to have attempted to translate into oils in his Diploma work at the RSA, the impressionistic *Midsummer* (1892: RSA, Diploma Collection) – crown and effectively terminate an impressive decade of artistic progress.

Guthrie had received a gold medal at the Munich Exhibition of 1890, not, as his friends had hoped, for *In the Orchard* but for a portrait of the *Reverend Andrew Gardiner* (1885: NGS), painted following a period of despair in which he nearly abandoned painting. It seems likely

that this was the beginning of his successful career as a portraitist of many of the notables of the day, culminating in the herculean *The Statesmen of the Great War* (1930: NPG). A clear debt to Whistler's *Miss Cicely Alexander* appears in Guthrie's *Miss Jeanie Martin* (1896), but for the most part his later work – much interrupted by his long tenure of the presidency of the RSA – deals with male sitters.

Guthrie's great friends and brother artists E. A. Walton and Joseph Crawhall each made profound – and profoundly different – contributions to the School in its early realist phase. The portrait of *Joseph Crawhall (1884: NGS)* by Walton was originally inscribed 'Joe Crawhall, The Impressionist, by E. A. Walton, The Realist', an affectionate joke between two young artists which contains more than a grain of truth. Although both practised in oils, Crawhall is usually thought of as a master of drawing and watercolour, and some of Walton's most significant works from his early maturity are in small-format watercolour. Walton's *In Grandfather's Garden* (1884: private collection), *En Plein Air* (1885: private collection), *The Herd Boy* (1886: NGS) and *The Gamekeeper's Daughter* (1886: GAG), particularly the two latter, are sensitive and contemplative works which achieve poetic stature. Walton exhibited a few other

watercolours of this type of subject, but these examples of his talent in watercolour are rare, although he was throughout his life a frequent and distinguished landscapist in the medium. Rather later than these, probably, is his undated oil *Bluette* (*c.*1889–90: NGS), which shows a young girl as pretty as her name holding blue flowers, against a freely painted landscape background.

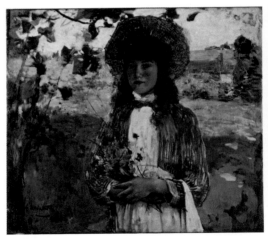

12. Edward Arthur Walton, *Bluette,*
National Gallery of Scotland

This charming picture is an early example of Walton's skill as a portraitist, a field in which he was increasingly engaged after his removal to London in 1894 where Whistler, a friend

since the successful 1891 campaign orches-
trated by Walton to have Whistler's *Portrait
of Thomas Carlyle* (1872–73) purchased by
Glasgow Art Gallery, became a neighbour at
73 Cheyne Walk, in a house that C. R. Ashbee
had designed for Walton. Walton and Whistler
remained on good terms and Walton was one
of the pallbearers at Whistler's funeral in 1903.
Walton's other neighbour in Cheyne Walk was
the painter Philip Wilson Steer.

In 1899, Walton was one of four artists –
the others were Lavery, Henry and Roche –
involved in a major project to provide mural
decorations for the Banqueting Hall in Glasgow
City Chambers, where the results can still be
seen in the extremely imposing room reached
by two sumptuous flights of marble staircase.
Walton's contribution rises to the challenge of
the very large scale with a depiction of a medi-
eval fair on Glasgow Green; Roche and Henry
are somewhat less successful, and Lavery departs
altogether from the medievalizing brief in a rare
essay in modern industrial realism, *Shipbuilding
on the Clyde*, which is not unreminiscent of
William Bell Scott's work at Wallington Hall.
In 1903 Walton was persuaded by his friend
Guthrie (who had been elected President of the
Royal Scottish Academy in the previous year)
to return to Edinburgh. Here he specialized in

portraiture, numbering *Andrew Carnegie* (1911: University of St Andrews) among his sitters. At the same time he resumed his painting of landscape, particularly of Galloway, and he held several exhibitions of these paintings, usually at Alexander Reid's gallery in Glasgow. Though executed *en plein air*, they show a move away from the realism of the 1880s towards a more impressionistic manner of painting.

Walton referred to his friend Crawhall as 'the Impressionist'. An enigmatic and taciturn man whose circumstances allowed him to paint purely for his own amusement, Crawhall was also called 'the Great Silence' by his friend and fellow member of the Tangier Hunt, R. B. Cunninghame Graham, with whom Crawhall shared a passion for horses. A brilliant horseman whose favourite pastime was riding to hounds, Crawhall might have stepped from the pages of *Memoirs of a Fox-Hunting Man*. His two short months of training in Paris under Aimé Morot in 1882 were clearly of much less importance to his development as an artist than the sympathetic encouragement and sound practical advice of his father, an inventive gentleman-artist who taught his son to draw from memory. Crawhall heeded the advice and cultivated a phenomenal visual memory which enabled him to reduce to a rapid shorthand an exquisite,

vibrant technique as a draughtsman and to capture the most fleeting appearance, above all of animals and birds in motion. His production was small; most of it was collected immediately by two main supporters, William Burrell, who acquired more than 140 of Crawhall's pictures, and T. H. Coats, and a few other connoisseurs. With Crawhall, technique was always subordinate to observation and design; the resulting portrayals of horses or birds combine the spontaneity of an instant's impression with the truth to type of *animalier* or sporting art. This is done with a consummate economy of means in such celebrated masterpieces as *The White Drake* (*c.*1890: NGS), painted in gouache on brown holland, *The Pigeon* (*c.*1894: Burrell Collection), or *The Jackdaw* (*c.*1900: National Gallery of Victoria, Melbourne).

As single studies of birds these examples represent a pinnacle of perfection even by Crawhall's ruthlessly self-critical standards and show a developing sophistication in the elimination of all inessential detail and indeed of all hesitancy in line or weight of brushstroke that would retard the effortless fluency and immediacy of the final effect. In an earlier *tour de force, The Aviary* (1888: Burrell Collection), that showed the fashionably dressed sisters of Crawhall and Guthrie dwarfed perspectively

by the other gaudily feathered occupants of the parrot-house, Crawhall stretches the conventional medium of watercolour (mixed apparently with a little Chinese white) to the limits of its capacity. The result is brilliant indeed, but the discrepancies of handling or surface that have been noted with regard to the 'Kodak' realism of Guthrie and Walton are also evident here, in the sense that the tiny human figures which are 'in focus' are treated with more 'finish' than their surroundings.

Crawhall himself, according to Bury, was dissatisfied with this work and had to be restrained from consigning it to the usual fate of anything that did not meet his exacting standards, summary destruction. It seems to have been approximately at this period that Crawhall began the fruitful experimentation with a fine-woven textile support – brown holland – which became the preferred ground for the decoratively simplified works of his maturity.

Crawhall's precise chronology has never been satisfactorily established, but three very beautiful equestrian subjects in *The Race Course*, *The Flower Shop* and *The Farmer's Boy*, all in the Burrell Collection, suggest a clear line of development. Each is painted in gouache on holland. *The Race Course* is an immensely complex composition – the wonderful racehorse, jockey

up, led by the stable lad and watched by the owner and his fashionable lady all in the foreground and, in the background, the stand full of hundreds of spectators painted in Melvillesque shorthand – which has slightly experimental awkwardness, just as the technical difficulties of applying gouache to textile result in a somewhat uneven handling of the pigment.

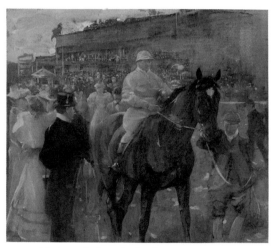

13. Joseph Crawhall, *The Race Course,*
© Culture and Sport Glasgow (Museums)

The Flower Shop, partly through the selection of a simpler subject, achieves a more satisfactory unity of style – the dark form of the horse silhouetted against the bright flowers in the

shop window – while the perhaps slightly later *The Farmer's Boy*, articulated by a series of gently curving lines which proclaim the 1890s, finally resolves surface and design in effortless unity. The absorbency of the textile support requires a more loaded brush and the greater weight of pigment in turn confers a more solid and less flickering and variegated effect, while the brown colour of the holland contributes to the tonal unity of the picture, just as its fine weave helps unify its surface. The way was now clear for the consciously decorative single studies of birds mentioned above, which miraculously blend spontaneity of application and instantaneity of vision with the most exquisitely balanced effects of bold colour and *mise en page*.

Earlier, the Glasgow School's origins were traced to two friendships, the first between James Guthrie and Edward Arthur Walton and the second between William York MacGregor, 'the father of the Glasgow School', and James Paterson. The pictorial evidence in support of the latter two friends as the originators of the early realism of the Glasgow School makes up in quality what it lacks in quantity. Painting did not come easily to MacGregor, as we learn in Paterson's *Memoir*, and ill-health and the necessity of foreign travel further combined to reduce his output (crippled by asthma, he was

obliged to move from Glasgow to Bridge of Allan in 1886 as well as visiting South Africa in 1888 in the hope of a cure). MacGregor's friend Paterson described him as a serious, shy man who relished a good sermon, drank little or nothing, but liked a good cigar. *Crail* (1883: Smith Art Gallery and Museum, Stirling) and *A Cottage Garden, Crail* (1833: private collection) are unadorned, masculine works of obvious integrity but hardly prepare us for the artist's masterpiece of the following year.

14. William York MacGregor, *Crail,*
Stirling Smith Art Gallery

In 1884 MacGregor, who had trained under Legros at the Slade, painted several big canvases of vegetables, of which only one, *The Vegetable Stall* (1884: NGS) can now be traced.

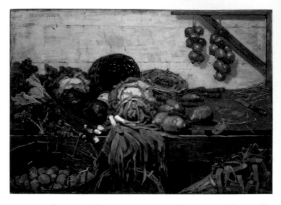

15. William York MacGregor, *The Vegetable Stall*,
National Gallery of Scotland

This picture marks the climax of the first phase of the Glasgow School's development. Whereas the early work of Guthrie, Crawhall and Walton indicates mastery of an existing idiom, *The Vegetable Stall* is a picture which it is impossible to ascribe to any outside influence, and its bold realism and confident handling are equally astonishing. Stanley Cursiter (1887–1976), a former Keeper of the National Galleries of Scotland, described how Oskar Kokoschka, seeing this picture in the Gallery for the first time, exclaimed, *'To think that the picture was painted before I was born – and I never knew!'*

The work demonstrated in convincing fashion that the imitative truth or realism of

plein-air painting might be of secondary value to the truth of reality reconstructed in terms of artist's vocabulary of form and colour, with the brushstroke as the smallest unit of the composition. In other words, reality is rendered in a painterly style that does not at the same time lose its own integrity.

The Vegetable Stall was to be MacGregor's masterpiece; ill-health forced him to leave Glasgow in 1886 for the cleaner air of Bridge of Allan, and then for South Africa in 1888–90, and when he returned the more progressive Boys had overtaken him. However, later works, such as *A Rocky Solitude* (exhibited 1896: NGS), show that MacGregor retained something of the virile, austere quality of his earlier period later in life, when we find him exhibiting in Edinburgh with the much younger artists of the Society of Eight and expressing admiration for the paintings by Gauguin shown at the Society of Scottish Artists exhibition of 1913 (Paterson *MS*).

James Paterson (1854–1932), who had known MacGregor since school days and remained a close associate, and whose correspondence with MacGregor is our main source of information concerning him, had studied in Paris during the years 1874–76 and 1879–83 and in an account of those years in the fifth

number of the *Scottish Art Review* he recalled the emphasis his French masters had placed on tonal values in painting.

Paterson's *Moniaive* (1885: HAG) is a thoughtful and competent application of the system of tonal unification Paterson had learned in France; it has a smoother and more assured, less experimental appearance than the other Glasgow School landscapes by Crawhall, Guthrie, and Walton which have just been mentioned.

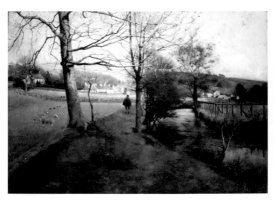

16. James Paterson, *Moniaive*, © Hunterian Museum and Art Gallery, University of Glasgow

Paterson was never to be one of the front runners in the rapidly changing succession of leaders of the Glasgow School.

CHAPTER 3

Grez-sur-Loing

IN THE EARLY 1880s the Glasgow School
was slowly coalescing in Scotland through the
gradual amalgamation of the two groups of
painters who surrounded Guthrie in summer
and MacGregor in winter. At this time a third
group was studying and painting in France. Sir
John Lavery (1856–1941), Alexander Roche
(1861–1921), William Kennedy (1859–1918),
and Thomas Millie Dow (1848–1919) painted
outdoors, at Grez-sur-Loing, where they were
joined by William Stott of Oldham, and the
critic R. A. M. Stevenson, adding to the small
colony of British artists and writers who had
recently included Stevenson's cousin Robert
Louis Stevenson. The composer Frederick
Delius was also resident at Grez at the same
time as the Glasgow painters, but Lavery's auto-
biography gives no indication that there was any
real contact between them.

Lavery's work at Grez is exemplified by *The
Cherry Tree* (1884: Ulster Museum), which
bears a considerable general resemblance in its

unified tonality to Paterson's *Moniaive* picture, with the significant difference that Lavery shows great confidence in introducing human figures on a quite large scale into his tonal scheme, without any discrepancies of handling.

The chief influence on Lavery during his French stay, however, was not his older contemporaries, the Impressionists, but their chief 'vulgarizer' (as Lucien Pissarro called him), Jules Bastien-Lepage.

Lavery had known Marie Bashkirtseff, Bastien-Lepage's disciple, and had encountered and received advice from Bastien-Lepage himself in Paris. Lavery followed Lepage briefly as a practitioner of his 'grey impressionism', but the influence of the later Manet rapidly began to assert itself in Lavery's work, paradoxically after he had returned to Britain in 1884. The Manet memorial exhibition was held in Paris in January 1884, and it is at least probable that Lavery visited it.

Lavery tells us that his decision to settle in Glasgow rather than London was made in 1883 when he saw Guthrie's *To Pastures New* at the Glasgow Institute. In 1885 he painted and exhibited at the Institute a canvas which sums up most completely his early, French-derived realism, *The Tennis Party* (AAG). In it he seems to put into practice Bastien-Lepage's advice on

capturing the human figure in action. Lavery remembered this as:

'Always carry a sketch-book. Select a person – watch him – then put down as much as you remember. Never look twice.'

Lavery's comment was that from that day on he became *'obsessed by figures in movement, which resulted in The Tennis Party.'*

This picture immediately stamps Lavery as possessing greater natural dexterity than any of the other Glasgow painters, and it is not spoiled by the over-facile virtuosity which creeps into his later work. Fittingly, it was awarded a Gold Medal at the Paris Salon of 1888.

17. Sir John Lavery, *The Tennis Party,*
Aberdeen Art Gallery & Museums Collections

It is arguable that Lavery was at his best in the 1880s. A series of fifty small canvases depicting the events of the Glasgow International

Exhibition of 1888 are as impressionist in the French sense of the word as perhaps any work by a British painter at this date. A *plein-air* example like *The Musical Ride of the 15th Hussars during the Military Tournament at the Glasgow International Exhibition* (DAG) or an interior such as *The Dutch Cocoa House at the Glasgow International Exhibition 1888* (NGS) show a complete assimilation of the French style, although the nocturnal scenes, painted with equal brilliance, seem indebted to Whistler, whose *Sarasate* portrait provided clear inspiration for Lavery's portrait of *R. B. Cunninghame Graham* (1893: GAG).

The same International Exhibition gave Lavery his first important portrait commission – to paint the *State Visit of Queen Victoria to the City of Glasgow, 1888* (1890: GAG). As a direct result of its success much of Lavery's later work belongs to one of the less interesting manifestations of painting in his own period – fashionable portraiture – a field in which he was surpassed probably only by Sargent and Orpen, and in which he achieved success on a transatlantic scale. He was to number Shirley Temple, Pavlova, Lady Diana Cooper, Lloyd George and his friend and pupil Winston Churchill among his sitters.

Lavery moved to London in 1896 and in 1898

became Vice-President of the International Society of Painters, Sculptors and Gravers, of which Whistler was President. When Whistler died in 1903, Macaulay Stevenson wrote Lavery a letter (Tate Gallery Archive) which typically combines the zealotry of Stevenson as the prophet of the gospel of modern art with his usual impish irreverence and is worth quoting *in extenso.*

'To you it will be a more personal loss than to some of us who are nevertheless all at one in appreciation of his transcendent genius and admiration for his inimitable personality. He held the torch for Europe and indeed the world when even Japan was infected with the evils of the accursed Protestant movement – every man doing what was right in his own eyes – which was usually very far wrong – no authority no noble tradition – the R. A. and the Salon all in their anecdotage ... I was immensely tickled at that International meeting to see you in the chair. You did it so delightfully badly. Worse even than Henry ... that's why you're the right man for the job. [Stevenson concludes ringingly] *Landscape art will yet write the Bible of His Revelation for the Common people.'*

Stevenson studied at the Beaux-Arts in Paris,

and although his nocturnal landscapes show the inevitable influence of Whistler, his chief inspiration seems to have been Corot. On their return from Paris, Lavery's friends William Kennedy, Alexander Roche and Thomas Millie Dow painted several pictures which show French inspiration. These artists, like many of the Glasgow School painters, are minor figures who briefly demonstrate the catalytic effect which the movement had on its members.

Kennedy (regarded by Macaulay Stevenson as one of the more important members of the early group) began robustly as a powerful and accomplished realist, attested by the interesting group of his early watercolours, mostly of military subjects, now in Stirling Castle Museum.

18. William Kennedy, The Deserter,
© Culture and Sport Glasgow (Museums)

The Deserter (1888: GAG), a subject which might have appealed to Daumier, is not only convincing in its monumental treatment of the working-class central figure, but shows mastery of tonal unity and draughtsmanship of a high order.

Having settled near Stirling on his return from France in 1885, Kennedy later paid many visits to Berkshire, attracted by its rural charm, and then, in ill health, settled in Tangier where Lavery had a house. He died there in 1918.

Similarly, *The Harvesters* (Paisley Art Gallery) and the masterly pastel study for it reveal Kennedy's technical sophistication in an unorthodox composition which looks very French. Kennedy painted *Stirling Station* (*c.*1888: GAG) in an evening light which shows less of Monet's influence than might have been expected from the subject, and more than a little of Whistler's. The glowing lights and the cloud of steam produce a decorative as well as realistic effect.

In fact the picture belongs to a Glasgow School group of nocturnal subject-paintings which begin to appear at about this point in the group's developments, in the hands particularly of Roche, Guthrie, Henry and Hornel. At least one of the series Lavery painted during the Glasgow International Exhibition shows a

night scene lit by bright lanterns (1888: private collection). Kennedy, however, did not move forward from the territory he had convincingly conquered in *Stirling Station,* and *The Fur Boa* (*c.*1892: GAG), though a vivacious portrait, harks back to the realism of Bastien-Lepage, just as *Homewards* (*c.*1892: GAG) relates (as Elizabeth Bird has recently shown) to a picture by Anton Mauve then in the collection of T. Hamilton Bruce in Edinburgh, and which appeared in the International Exhibtion of 1886. Nevertheless, the latter work with its impasted colour and lyrical celebration of an orchard in blossom, indicates a genuine response to the beauty of a bright spring day, as *The Harvest Moon* (*c.*1890), illustrated in Martin's book of 1897, is suggestive of the mystery of a moonlit autumn dusk. But Kennedy's later military and North African subjects show diminished originality.

Thomas Millie Dow began to exhibit regularly at the Glasgow Institute in 1880, and lived in the city from 1887 to 1895 before moving to St Ives. He was a close friend of William Stott of Oldham and shared with Stott a concern for tonal values and a silken finish which is at odds with the general tendency of the Glasgow School artists towards vigorous handling. His early flower pieces seem all to have disappeared,

surprisingly, as his gifts were those of a decorator and the flower subjects look well in period journals. On the other hand, his rather static or stiff figure drawing made him less well suited to the kind of allegorical figure painting represented by two large works in the Dundee Gallery, *The Herald of Winter* (1894), which represented Dow in Martin's book, and *Sirens of the North* (1895).

The Herald of Winter shows a winged figure in a white robe standing on the crest of a hill sounding a horn, while migrating geese fly past. The picture owes something to the mural style of Puvis de Chavannes and is not far in concept from John Duncan's slightly later work in a similar vein.

19. Thomas Millie Dow, *Sirens of the North,*
Dundee Art Galleries and Museums

Sirens of the North, too, is a faintly comical treatment of the theme of the *femme fatale* dear to the symbolists of the 1890s, where woman often appears as sphinx, harpy, or here, as mermaid, representing a threat to men as the hesitant oarsman, who approaches in his eminently sinkable skiff, appears to be fully aware.

The Hudson River (1885: GAG) is a much more prepossessing work, partly because it is less pretentious but not less ambitious, and adopts the same tonal approach as Paterson's *Moniaive* already discussed, but using a lighter palette.

Chapter 4

Decoration

FEW WORKS OF the 1880s are more quintessentially of the Glasgow School style than Alexander Roche's *Good King Wenceslas* (1887: private collection), which shows the page following the king through snow and uses gold leaf to indicate Wenceslas's sainthood. The subject is one that might have appealed to the democratic humanitarianism of Whitman or Thoreau whom the Boys admired, but it is treated without bombast, and the page is the main figure in the composition. The decorative gold nimbus in the background adds an element of mystery and spiritual significance to the winter landscape, and is in a sense repeated in the incised Japanese seals with which the frame is decorated, making a contrast with the very boldly painted snowscape. Roche's later career was devoted almost exclusively to portraiture. *Miss Loo* (1889: private collection) is an unusually well-composed example, but it does not possess the originality of *Good King Wenceslas*, which appears to be unique in Roche's *oeuvre*.

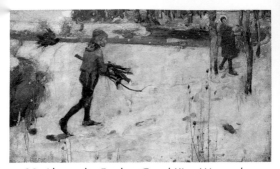

20. Alexander Roche, *Good King Wenceslas,*
Private Collection

Arthur Melville (1855–1904), a native of Forfarshire in north-east Scotland, had asked for an introduction to Guthrie when the latter's *The Highland Funeral* was first exhibited at the Glasgow Institute in 1883. Like W. Y. MacGregor, he was sufficiently senior in age and experience to the Boys to be something of an older brother to them. In 1875 he had entered the life school of the Royal Scottish Academy, where he encountered the established painters John R. Reid and Robert McGregor. He was a pupil of J. Campbell Noble, and he received occasional instruction from William McTaggart. These four artists were formative influences on Melville's work. By the time of his first visits to Cockburnspath with Guthrie, Walton and Crawhall, Melville had also received training

at Julian's in Paris and had completed a two-year painting tour from Karachi to Baghdad, crossing Asia Minor on horseback (one wonders whether Crawhall and Melville ever found time to discuss anything as mundane as watercolour painting) with a series of adventures and narrow escapes which rival those of the celebrated Orientalist painter David Roberts and make him seem, with his 'big, handsome, courageous cavalryman presence', like a character from the romances of Robert Louis Stevenson, whom he met at Grez in 1878. He was the first of the group to be elected an Associate of the RSA in 1886.

Melville had a considerable body of work to his credit by the time of his first encounter with Guthrie and the others. *The Cabbage Garden* (1877: NGS), a small work, emerges from the rural realism practised by W. D. McKay (1844–1924) and associated with the Lothians. It prefigures much work typical of the Glasgow School in a similar vein – for example Walton's *A Berwickshire Fieldworker* (1884: TG) or Henry's *A Cottar's Garden* (watercolour, 1885: NTS) – in its painterly vigour.

Paysanne à Grez, dated 1880 (private collection), like the earlier work, unsentimentally gives equal importance to both the landscape and the figure subject, and marks a further

advance in decorative terms, with its strong colour and painterly surface. We read in the *Oxford Dictionary of National Biography* that this painting:

'represents a significant departure from the consistent predilection towards naturalism evident in contemporary Scottish painting. The innovative, geometric design utilized areas of flat colour in the wall and blue shutter, interacting with the stripes of the blouse and abstracted forms of the head-dress and vines to create a decorative whole . . .'

– a good analysis. Painting of this strength cannot have failed to capture the imagination of the Cockburnspath group.

Audrey and her Goats (begun 1882: TG), a Shakespearian subject which Macaulay Stevenson tell us 'cost the artist an infinity of time and trouble' over several years, has an inchoate quality which is surprising in an artist of Melville's very real virtuosity as a watercolourist. It is clear that for Melville as for Guthrie, at this stage a struggle was taking place, the very birth-pangs of a new style. In the same year that Guthrie was painting *In the Orchard*, 1885, Melville also produced one of the most original works by any member of the Glasgow School up

to this point, the brilliant and bold *Red Poppies* (private collection).

The *Portrait of Mrs Sanderson* exhibited at the New Gallery in London in 1889 – and pronounced by Whistler the best portrait shown in London that year – in Macaulay Stevenson's words was *'attempted on no less than three separate canvases and carried each a long way towards completion ere he reached the fine expressive result which the finished picture shews.'*

But no such hesitancy troubled the artist at least in two major landscapes with figures dating from his trip to Spain with Frank Brangwyn in 1892, namely *A Spanish Sunday: Going to the Bullfight* (Dundee University) and *The Contrabandista* (private collection). These two works infuse into the more intractable oil medium the vitality and spontaneity of Melville's highly individual watercolour style, although his oil technique is quite different.

A Spanish Sunday shows Melville using long sweeping brushstrokes which impart movement to the whole work, in such a way that the brushstroke is simultaneously descriptive and frankly decorative. The artist's harmonic knowledge is evident in the single bold accents of colour placed at telling intervals in the design, in unexpected touches of lemon yellow or bright red, while over the whole composition there hangs

a realistic suggestion of the faint haze of a very hot day in a terrain where the dusty earth reflects back the sun's glare.

21. Arthur Melville, *A Spanish Sunday:
Going to the Bullfight*,
University of Dundee Museum Services

The Contrabandista is an equally original work. There exist at least two smaller versions of the composition in oils, and the full title of the finished work is *Study: The Contrabandista*. Here, shadows cast on a hill by poplars which are not shown but understood to be behind the spectator, are bluer than the sky itself, and the white cloud in the sky is as solid as the hill

down which a mule train descends in a cloud of fine dust. The subject is exotic (smuggling, a Spanish hillside) and the title emphasizes this. The composition is of a consciously decorative flatness and the shapes and colours schematic in a way that recalls Monet's series of poplars on the Epte of similar date.

From the same period also come a small group of landscape panels which show even greater confidence in the abstract possibilities of form and colour, fully realized finally on a large scale in *The Chalk Cutting* (private collection) dated by Mackay to 1898. The richly decorative, large-scale portrait of 1897, *The White Piano* (Harris Museum, Preston), resolves the conflict between realism and decoration as successfully as any Glasgow School portrait.

Among Macaulay Stevenson's papers was Melville's brief response to a biographical questionnaire sent by Mrs Macaulay Stevenson to contributors to the crucial Grosvenor Gallery and Munich shows of 1890. Melville's reply was dated 1890, as were those of other respondents including Kennedy, Dow, Paterson, Roche, MacGregor, Corsan Morton, Crawhall and Lavery. Like John Lavery (who was from Belfast) and Crawhall (from Morpeth), Melville (from Loanhead of Guthrie in Angus) was originally attracted to the group by the

work and personality of James Guthrie, before being drawn to London, as were George Henry, Alexander Mann, E. A. Walton, James Christie and of course John Lavery. The Glasgow School was like Proust's fountain: its appearance of permanence was illusory. But Melville's Glasgow School credentials are nonetheless impeccable. He attended W. Y. MacGregor's seminal winter studio in Glasgow and painted with the Boys at Cockburnspath in summer. He subsequently exhibited with them from Saint Petersburg to Barcelona in Europe, and ubiquitously in North America and Australia.

Melville is best known as a watercolourist, and with good reason, for this was his preferred medium in which he developed a highly individual virtuosity. *The Turkish Bath* (Paris, 1891: Keith Collection) may remind one of Gérôme in its exoticism and use of an elaborately architectural interior, just as the *Arab Interior* (oils, 1891: NGS) is reminiscent of the work of the Orientalist John Frederick Lewis (1804–1876), an obvious model for such a subject; but the two works are fascinating as demonstrating the ease with which Melville adopted and as quickly abandoned two contrasting styles – Beaux-Arts and English romanticism – at this early stage.

The Call to Prayer: Midan Mosque, Baghdad (1882: private collection) exemplifies one of the

two main types among the watercolours which originate from Melville's two-year painting tour of North Africa and the Middle East. It has an architectural background and an amazingly numerous group of figures wearing the colourful jellabah. While the architectural subject, the sky and foreground are painted with flat washes, the crowd is suggested in passages of heavily worked pigment which has been wiped, sponged, run and dripped onto the page. The busy crowd scene thus provides an exciting staccato counterpoint to the legato of the rest. In terms of colour Melville can seem surprisingly subdued in these earlier works, which retain a tonal reticence much in contrast with his later style. The second of the two types of watercolour mentioned comprises the interior scenes which tend to be broader in treatment: *A Cairo Bazaar* (1883: GAG) is an example. Here, the figures are much larger in the overall composition, the colour is warmer and the brushwork more conventional.

Melville's fully developed style is revealed in the mid-1880s, and announced by the astonishing *Awaiting an Audience with the Pasha* (1887: private collection). This large watercolour allies the formal counterpoint analysed above to a daring chromaticism of hot colours, and technically (in terms of beautiful

draughtsmanship and unbelievably intricate brushwork) probably surpasses anything ever done by Melville. It prepares the way for such remarkable examples of decorative pyrotechnics, full of realistic suggestion, as *Bravo Toro!* (exhibited 1899: V&A) and *Banderilleros à Pied* (1890: AAG).

Melville was resident in London after 1889, but died prematurely in 1904 from typhoid contracted on a visit to Spain. Writing in 1891, Macaulay Stevenson commented justly that *'the value of such a personality* [as Melville] *to the young Scottish School has been incalculable.'*

Melville was evidently an influence on the style of the more mysterious J. W. Herald (1859–1914), who also studied at Herkomer's school at Bushey and lived in Croydon until 1899 when he returned to live in his native Angus. Erratic, a recluse who disposed carelessly of his best completed work, Herald possesses a haunting style very different from the vigorous Melville, although technically there are considerable affinities between the two. *The Portico* (*c.*1898: private collection), however, suggests the influence of Conder rather than Melville in its delicate use of colour.

CHAPTER 5

Pastoral

A NEW PHASE IN the development of the Glasgow School began in 1885 with the return of Edward Atkinson Hornel (1864–1933) from his studies in Antwerp and the beginning of his friendship with George Henry, whom he met in Kirkcudbright in the same year. George Henry had been with Walton and Guthrie at Brig o' Turk in 1881 and exhibited two small pictures painted there at the Glasgow Institute in the following year. He was in Eyemouth in 1883, near Cockburnspath, where Guthrie and Walton were to be found, and in the winter of that year worked in W. Y. MacGregor's Glasgow studio, accompanying MacGregor on a painting trip to Dunbar in the following spring. Art historian Roger Billcliffe convincingly traces the influence of Guthrie on Henry's early work. A comparison of Henry's *Noon* (1885: private collection) with Guthrie's *In the Orchard* of 1885–86 reveals similarities in subject, colouring and technique, with the Henry picture if anything slightly ahead in its progress from

realism towards symbolism: in *Noon* the girl in her peasant's apron stands in flattened profile in the shade of an equally flattened tree trunk, while the shaded ground and the sunlit field beyond halve the composition into two horizontal bands of colour. Henry's grasp of style seems the firmer.

E. A. Hornel's teacher Verlat taught his pupils to handle paint vigorously *'so that one was painting and drawing at the same time'*, as Hornel later said. This Belgian influence is visible in an impressive, if conventional, early work by Hornel, *The Bellringer* (1886: private collection), which shows Kirkcudbright's 'town crier', Winefield Nellens, in a composition and pose strongly dependent on two very similar paintings of elderly men in uniform which Hornel painted in Antwerp (both 1885: Nottingham Art Gallery and NTS [gift of Mrs L. Walmsley]).

Hornel's *Resting* (1885: private collection), exhibited at the Glasgow Institute in the same year, so resembles the Henry *Noon* that an indebtedness of the former to the latter seems clear, as the Hornel picture is comparatively tentative in handling. Again, measuring the progress of the two friends by comparing two works of 1887, Hornel's *In Mine Own Back Garden* (HAG) and Henry's *Sundown* (HAG),

the conscious decorativeness of the Henry picture stands in marked contrast with the early realism of the Hornel. Another Henry work of 1887, *Gathering Mushrooms* (private collection), which Henry thought enough of to send to the Munich exhibition of 1890, is a daringly symbolist concept both in its schematic design and in its rather fey subject (to Victorian eyes) of a girl gathering mushrooms by the light of the full moon, although its handling is almost crude. Henry's *Autumn* (1888: GAG) is a woodland scene in which the figure of a girl can be inferred, her face only being clearly discernible, among a pattern of leaves and slender tree trunks, painted with masterly variations of handling from palette knife to delicate brushwork.

Not by coincidence, Hornel's most ambitious work of 1888 has the same title of *Autumn* (private collection); this is a ravishingly painted small picture in which the boldness of the application with the palette knife is matched by the poetic subject which suggests a mystical connection between the girl and the tree with its apples.

The progress of the two artists to this point tends to support the contemporary view of Macaulay Stevenson that Henry, on meeting Hornel in Kirkcudbright, offered friendly practical criticism of the younger artist's work by

showing him his own, and that Henry's at that early stage was *'the original mind'*, although he qualifies this by adding that Hornel's *'is no secondary mind'*. The *Notes* of 1891 add of Henry that:

'In any walk of life he would be a remarkable man ... Not a little of what is best in the work of some of (the others' work) is at least partly due to Henry's generous help – both the help of actually working on some of the pictures and the more intangible yet nonetheless real influence of his stimulating personality.'

It remains a matter of conjecture whether Hornel met James Ensor during his stay in Belgium but certainly in 1893 Hornel sent work to the final exhibition of the artistic group Les XX ('Les Vingt') – of which Ensor was a founder – and at least one work of Hornel resembles that of the Belgian master in its macabre subject-matter: *The Brownie of Blednoch* (1889: GAG), an apparition which in turn prefigures the 'spooks' which came to haunt some artists of the 1890s. Also in 1889 Hornel painted a beautiful little picture titled *The Goatherd* (private collection) which takes one stage further the tendency to represent landscape as a decoratively flat pattern united by strong colour and

a richly nourished and increasingly fragmented surface.

Hornel and George Henry shared a studio in Glasgow, painted in the country around Kirkcudbright where Hornel had been brought up and where he had ancient family roots, and, as Stevenson asserts, even painted on each other's pictures. Two large pictures, *The Druids; Bringing in the Mistletoe* (1890: GAG) and its companion *The Star in the East* (1891: GAG) are the best-known examples of their collaboration. Hornel brought his considerable antiquarian knowledge to bear on *The Druids* which is full of Pictish symbolism and interestingly anticipates something of the Celticism of the later nineties.

The decorative approach to painting evolved by Hornel and Henry in the late 1880s had its most remarkable result however in Henry's *A Galloway Landscape* (1889: GAG). In his autobiographical *A Painter's Pilgrimage*, the author and painter A. S. Hartrick, who had known Gauguin at Pont-Aven and even painted a picture of Gauguin's house there (1886: private collection), wrote of Henry's picture:

'I have seen the spot where it was painted, a very ordinary field with a hill in it; but Henry introduced a blue burn, painted with a palette knife,

ᴧround it; then put a stain over all, and it became an object of derision for the man in the street as well as for the Glue Pot School, but an ineffaceable memory for any artist who has ever seen it.'

The Stevenson *Notes* agree that *'It is almost a literal transcript of a particular scene.'* The emphasis on arabesque and flat colour pattern in this painting represents a complete departure from the realistic descriptiveness of earlier Glasgow School landscapes.

22. George Henry, *A Galloway Landscape,*
© Culture and Sport Glasgow (Museums)

In the wider context of British painting, *A Galloway Landscape* is an extraordinarily

advanced work for 1889, and in the light of Mrs S. J. Peploe's assertion that the Glasgow dealer Alexander Reid (who was Henry's dealer) had known Gauguin in Paris – no doubt during his spell with Boussod and Valadon (formerly Goupil) in Paris in 1887 – it seems at least to be a reasonable hypothesis to link its novelty directly to Henry's exposure to Gauguin.

Hornel and Henry now embarked on a period of consolidation in a series of paintings which represent a high point in the achievement of the Glasgow School.

23. Edward Atkinson Hornel, *The Brook,*
© Hunterian Museum and Art Gallery,
University of Glasgow

Hornel's *The Brook* (1891: MacFie Collection, HAG) resembles *A Galloway Landscape* but unlike it contains human figures unorthodoxly posed against the landscape, or rather within it, so that they form with the landscape a pattern of rich colour in which the individual elements are difficult to distinguish from each other. The relevance of Monticelli to this kind of painting is clear. Equally decorative is *A Galloway Idyll* (1890: private collection). These are small pictures.

Hornel's confidence in his new manner is demonstrated in two large paintings in the following year: *The Dance of Spring* (1891: GAG) which resembles Ensor in its exuberant impasto and truculent vitality; and the powerfully painted *Summer* (1891: Walker Art Gallery, Liverpool), which was the first picture by any of the young Glasgow artists to be acquired by a public museum. The latter work is tightly composed in a swirling circle of movement.

Henry's work in the same period lacks the raw vitality of Hornel's but is increasingly concerned with static decoration as in *Blowing Dandelions* (1891: YCBA) and *Through the Woods* (1891: FAS). *Poppies* (1891: ECAC) unusually shows only the heads of four pretty girls among the flowers; this is a symbolist

treatment of the subject which distinctly antici-pates the Art Nouveau. A little landscape, *Barr, Ayrshire* (1891: NGS) is as fresh and modern looking as a Peploe, while *The Fruiterer* (1894: private collection), painted in a light key, is as sophisticated with its off-centre design as the other is artless.

CHAPTER 6

Japanese Interlude

WHEN HE WENT to Japan with Hornel in 1893, Henry produced much less than Hornel during their eighteen-month stay, and many of his Japanese pictures are in media other than oil. They consist in the main of delicate drawings and sensitive pastels which hark back to Sir James Guthrie's pastels of 1888 and 1890, and of watercolours which seem indebted to the watercolours produced by Sir Alfred East in Japan and seen in the Glasgow International Exhibition of 1888, as well as in the pages of the *Scottish Art Review* in the same year. The rather rare examples of Henry's work in oils from the Japanese visit are of fine quality and the ruin of a quantity of them on the return journey from Japan is a matter of real regret; but they seem to add little in stylistic terms to what Henry had already achieved.

It was left to Hornel to add an impetus of his own to the momentum of the decorative style which these two artists had initiated. Hornel's Japanese paintings are among the most exciting

of all the pictures produced by the Glasgow School. It does not detract from their originality to say that Monticelli's formal diffuseness and rich colour (which Hornel must have noted in the great International Exhibitions of 1886 and 1888 in Edinburgh and Glasgow, which included several works by Monticelli) are important elements in Hornel's style of the mid-1890s.

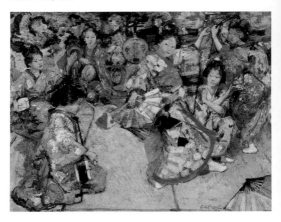

24. Edward Atkinson Hornel, *Japanese Dancing Girls*, Private Collection

In *The Japanese Garden* (1894: private collection) two girls are playing battledore and shuttlecock and the repetition over the whole surface of the canvas of the formal *leitmotif* of

the flashing smile that is the focal point of the design is a sophisticated device. About forty paintings from his Japanese tour were assembled by Hornel for an exhibition in the Glasgow gallery of Alexander Reid, who had been the main sponsor of the expedition. The exhibition received enthusiastic reviews and nearly every picture was sold.

Alexander Reid's exhibition of Hornel's 'Japanese' paintings in the galleries of the Société des Beaux-Arts marks the climax of the artist's association with Glasgow and the Glasgow School. The assurance and originality of these paintings must have appeared to many to mark the rise of a new leader of the School. However, by 1895 Hornel had become permanently resident in Kirkcudbright and had begun to do all his painting in the studio in the High Street, and although there was no abrupt cessation of good relations between Hornel and the other members of the School (Hornel continued to exhibit at the Glasgow Institute every year), there seems to have been a gradual weakening of ties. Hornel refused an associateship of the Royal Scottish Academy in 1901, to the annoyance of friends who had supported his nomination. In a letter to his friend the publisher Thomas Fraser (NTS) he wrote:

'Many thanks for your letter of congratulation. It will not surprise you to learn that I have declined the honour of Associateship. I am very happy as plain Hornel and I mean to remain such, as far as these trumpery affairs are concerned. I am not built right someway for wearing purple and fine linen. This decision will no doubt surprise some, gratify others, and disappoint few. I am quite indifferent ...'

George Henry was made a full member of the RSA in the following year.

As early as 1892, as a brief correspondence between Macaulay Stevenson and James Paterson shows (Stevenson *MS*), an amusing altercation had taken place involving two factions which, independently of each other, had attempted to set themselves up as the 'official' Glasgow School of painters. This piece of 'Glasgow school-boyishness', as Stevenson called it, symptomizes a malaise within the movement, and it comes as no surprise to find Hornel, in a letter to Stevenson of 13 August 1905, referring to the 'brotherhood' as something of the past. But the parting of the ways was certainly very much of Hornel's choosing.

CHAPTER 7

Kirkcudbright Idyll

IN 1901 HORNEL removed from his studio to Broughton House, also in the High Street in Kirkcudbright (and now a property of the National Trust for Scotland). Thereafter his time appears to have been equally divided between painting and other occupations connected with the fine eighteenth-century mansion that was his new home, including the creation of a Japanese garden. A considerable proportion of the correspondence with Thomas Fraser, which spans twenty-three years, is devoted to talk of gardening and the purchase of books for the library in Broughton House. It is obvious that Hornel gave a great deal of thought to the planning of his remarkable Japanese garden, and with Fraser's help he built up an excellent library which contains a unique collection of Burns editions, a manuscript collection, which includes items by Bishop Percy, Scott and Carlyle, and a comprehensive Galloway collection including works on local Dark Ages archaeology. Hornel added a studio to Broughton House, and a

gallery whose furnishings (including a huge Renaissance mantelpiece by his friend John Keppie of Honeyman, Keppie and Mackintosh, and a plaster cast by John Henning of the Parthenon frieze) are in markedly Victorian taste. In a word, then, Hornel's isolation from Glasgow and its School was partly due to that movement's increasing debility, and partly to the fact that Hornel had formed other interests which tied him to Kirkcudbright.

The paintings produced by Hornel between 1895 and 1907 reflect changes just described in his personal circumstances and in his relationship to the Glasgow group. These were the crucial years which saw the power and audacity of the thirty-year-old's style give way to the prolix and mannered charm of the middle-aged and elderly Hornel. They were also the years in which Hornel became the leader of a small group of Kirkcudbright painters, among them Bessie MacNicol (1869–1904), who painted a powerful portrait of Hornel shortly after his return from Japan (1896: NTS), W. S. MacGeorge (who had studied with Hornel in Antwerp), and William Mouncey, Hornel's brother-in-law.

Thomas Bromley Blacklock (1863–1903) trained in Edinburgh, but the influences on his work were his fellow Kirkcudbright artists E. A.

Hornel and Jessie M. King, whose very different styles are reconciled in Blacklock's attractive painterliness, which resembles Hornel's, while his subject matter resembles Jessie M. King's. Sir James Caw lists *Red Riding Hood, Bo-Peep* and *Snowdrop*, as well as several other titles in which

'children and fairies and the creatures of the wilds and the sea-shore live on terms of intimate companionship in an enchanted land.'

After 1895, Hornel's Monticelli-based handling and lighter palette (which never returned to the earlier rather sombre 'Glasgow School' richness) were a major influence on these artists.

After Hornel's return from Japan, says Sir James Caw, *'for some years he seemed to be in a cul-de-sac and made little or no progress'*. The large painting *The See-Saw* (1896) shown at the Glasgow Institute in 1897, although it has all the old exuberance – a quality that was soon to disappear from Hornel's work – is (as far as one can judge from a photograph) badly drawn and badly composed. After the successes of the Japanese period, such uncertainty comes as an anti-climax, and Hornel seems to have been content until about the turn of the century to produce atmospheric colour schemes whose

rich impasto and formal diffuseness recall Monticelli.

The Kelvingrove Art Gallery's *Fair Maids of February* (1899; later named *The Coming of Spring*) is an exception, however. As a contemporary writer noted it had *'much more precision than is usually observed by the painter'* and with its fine quality of paint and conventional drawing this work seems to foreshadow the insistence on *belle matière* which became so characteristic an aspect of Hornel's later style. The little girls who populate Hornel's pictures after 1900 are increasingly well-behaved and do the things that little girls were supposed to do: catch butterflies, pick flowers, and play ring-o'-roses, unlike their tomboy sisters in the earlier pictures.

It is hard to agree with a *Studio* critic of 1907 according to whom:

'Hornel paints the gamins of Kirkcudbright as Murillo painted those of Seville, with the uncompromising fidelity not of the satirist but of the true nature-lover, for whom the unkempt, ragged urchin engaged in the manufacture of mud pies is lovelier than the daintiest suburban miss in pink muslin ...'

Mud pies and unkempt ragged urchins are

conspicuously absent from Hornel's work after 1900. The fact that shortly after 1900 Hornel used photography for his figures provides proof, if any were needed, of his predominantly decorative intention; he was not remotely interested in psychological portraiture. According to the late Mrs E. Johnstone, who 'sat' for Hornel as a little girl and whom I interviewed in 1967, the models were grouped and posed by Hornel, photographed by a professional photographer, and then added as figures to a backcloth of flowers which Hornel painted *sur le motif,* that is, in nature, directly in front of the scene being rendered. Some of the Japanese photographs in Broughton House are beautiful in their own right.

Photography led Hornel to the practice of painting several versions of the same pose or grouping that were differentiated only by size or colour. But the later treatment of flowers is often magnificently rich and lyrical, and shows an interest in pattern-making (with the petals of the flower species in question providing a kind of modulus for the whole surface of the painting) which may owe something to Hornel's admiration for the Pre-Raphaelites. He was recorded in 1905 as saying that Madox Brown was *'the greatest modern British colourist'* and he

especially admired Madox Brown's Manchester Town Hall frescoes (1879–93), but the last word may be left with an old friend of Hornel's, the late Owen Bowen, who wrote to me in 1967 that Hornel

'treasured an old Paisley shawl, this he took with him when painting in the open, as an inspiration for a colour scheme.'

In connection with the later decorative phase of the School, another name must be singled out, that of Stuart Park (1862–1933). Park's whole claim to attention as one of the important members of the School rests on a small number of paintings of flowers produced in 1888–89. These paintings reveal a highly original use of simplified planes to denote surface and volume and their colour is most subtle, although the later examples have the cardboard appearance of an exhausted formula, for all their ingenuity.

As a slightly later development on the theme of the flowers, Park painted several single head-and-shoulder studies of pretty girls surrounded by flowers. Only one is known – *A Gypsy Maid* (DAG) – probably because these confections must have been highly saleable in their day and are presumably still in private collections.

These must be dated slightly later than the

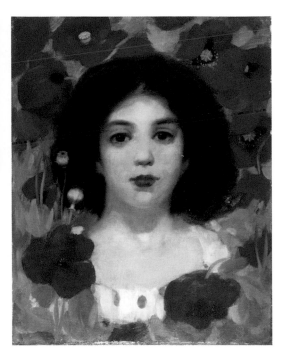

25. James Stuart Park, *A Gypsy Maid*,
Dundee Art Galleries and Museums

series just referred to, as they lack the rigorous
draughtsmanship of the 1888–90 pictures,
but they are lusciously painted and amusingly
comment on sensual temptation: one wonders
if the Dundee girl has been eating the poppies.

Park was a genuinely individual colourist and

developed a swift and sure painterly dexterity which can pall; but his flower paintings, which were sold in a popular one-man exhibition held every February in the McLellan Galleries and also abroad, preferably in their opulent Italian, carved giltwood or feigned-oval ebonized frames, can be wonderfully decorative. Each flower petal is formed by a single stroke, often with striking contrasts of dark flowers against a light background or *vice versa*.

CHAPTER 8

A New Art

PAINTINGS BY THE younger members of the Glasgow School around 1890, such as Hornel's *Young Girl* (1888: private collection), Henry's *Sundown* (1887: HAG), *Girl Gathering Mushrooms* (1888: private collection) and *Galloway Landscape* (1889: GAG), and above all the *St Agnes* by Charles Rennie Mackintosh's friend David Gauld, prepared the way in Scotland for a new art that came to be known as Art Nouveau and which deserves some mention here. It would concentrate on spiritual essences rather than on visual impressions of the material world. This contrasted with the evolving interpretation of realism which had provided the stylistic connections throughout the nineteenth century.

The prophetic *St Agnes* (1889: exhibited in Munich, 1890) by Gauld, painted in a *cloisonniste* style related to his very similar stained-glass designs for the Glasgow firm of Guthrie and Wells, demonstrates the elongations, the formalization, the pensive wistfulness, and

even the interest in vernacular architecture (in this case, that of Cambuskenneth – one of the Glasgow Boys' favourite painting locations) so characteristic of the new movement in Scotland.

Glasgow, Edinburgh and Dundee were each in turn the centre of creative activities which are surprisingly little related.

Gauld's *St Agnes,* as already noted, is dated 1889. In 1891 the French-trained Edinburgh artist Robert Burns (1869–1941) produced the drawing *Natura Naturans* (possibly inspired by de Feure and dated 1891 but only published as a wood-block engraving in Patrick Geddes's *The Evergreen* magazine in 1895), which at this early date confidently exploits the whiplash curve which became the Art Nouveau movement's hallmark.

French inspiration and an illustrative bias inform the graphic work of the main contributors – Burns himself, Charles Hodge Mackie (1862–1920) and John Duncan (1866–1945) – to *The Evergreen* magazine, whose four issues appeared in Edinburgh in the years 1895–97. With the designer–ceramicist Phoebe Anna Traquair (1852–1936), Duncan was the foremost of the Celtic revivalists in Edinburgh who also boasted two interesting disciples of Morris among their architects: Sir James Gowans and F. T. Pilkington, whose

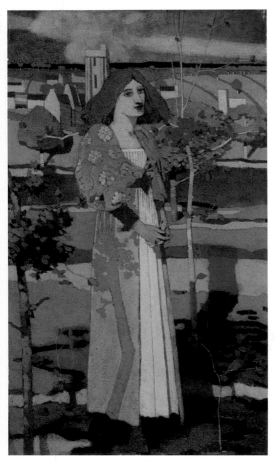

26. David Gauld, *St Agnes*,
National Gallery of Scotland,
(Purchased with the aid of the Art Fund 1999)

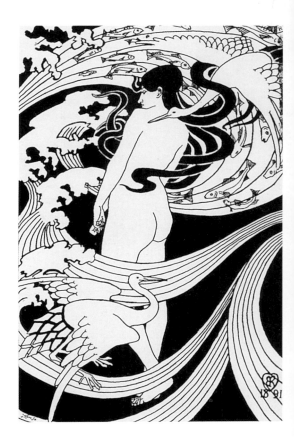

27. Robert Burns, *Natura Naturans,* printed in the
Spring number of *The Evergreen,* 1895
(Wood engraving by Augustus Hare)

Bruntsfield Church is the epitome of pictur-
esque illustration in architecture.

In Glasgow alone, however, more exotic
contemporary influences were at work and
Jessie Newbery, writing in 1933, recollected
the importance to Charles Rennie Mackintosh
and his friends of *'contact, through the medium
of* The Studio*'* with the work of the following
artists: Aubrey Beardsley (his illustration to the
play *Salome* by Oscar Wilde); illustrations to
Zola's *Le Rêve* by Carlos Schwabe; reproduc-
tions of some pictures of Toorop – a Dutch
artist; the work, architectural and decorative,
of C. F. A. Voysey. These artists gave an impetus
and a direction to the work of the painter and
glass artist Margaret Macdonald, the archi-
tect Charles Rennie Mackintosh (Macdonald's
husband), Macdonald's sister Frances and
Herbert MacNair, or, as they were known from
1894, 'The Four'.

The main direction of the new art style in
Scotland in the early 1890s was determined by
'The Four' at an early point in their respective
careers. In the realm of the graphic arts, this
flowering is nowhere seen to better advantage
than in the four surviving scrapbooks, preserved
by Agnes Raeburn and now appropriately in the
possession of the Library of Glasgow School
of Art, collected for circulation among the

contributors and their fellow students at the School in the years 1893–96, and known as *The Magazine*. This compilation of autograph work must rank as one of the most extraordinary ever produced by students at any art college, and it underscores Glasgow's pre-eminence in the development of the new style.

In the realm of the applied arts, Glasgow witnessed an immensely rich flowering of talent, partly inspired by the ever-encouraging presence at the Glasgow School of Art of Fra Newbery as Director. Apart from the 'The Four', such talent included: in furniture design, the major designers George Walton, Jane Fonie, E. A. Taylor and George Logan, the latter two producing many designs for the Glasgow firm of Wylie & Lochhead; in metalwork, Peter Wylie Davidson and many others; in stained glass, Oscar Paterson and Alf Webster; in embroidery and dress design, Jessie Newbery, née Rowat, Ann Macbeth and a host of feminine talent; in glasswork, the Clutha glassworks; in pottery, the Allander kilns. And finally, third in chronological order after Glasgow and Edinburgh, Dundee requires mention in any survey of Art Nouveau in Scotland because of the brief incandescence of George Dutch Davidson's career in the north-eastern city.

What sets Mackintosh apart from all his

contemporaries, however, is his ability to view all the branches of the visual arts in a kind of synaesthesia that allowed his search for new forms in one branch constantly to be enriched by explorations in another. The experimental and 'symbolist' watercolour paintings of the 1890s were one of the most rewarding avenues of exploration in terms of form and colour. The idea of form as symbol pervades Mackintosh's view of architecture and design. In the work of what other designer might we encounter a chair with a shaped backrail which frames the sitter's head like a halo, another with the hieratic solemnity of the throne of Minos; a games table formed (although gambling would certainly have been forbidden at Miss Cranston's) as a lucky four-leafed clover; or a revolving bookcase of tree-derived form; a library (at Hill House) whose panelling resembles angel's wings; an organ case (Craigie Hall) decorated with carved songbirds; another (Queen's Cross Church) with minims on a kind of vertical staff; a school (Scotland Street) with a mini-ature entrance for its infants; a School of Art (with its east elevation's reference to Maybole Castle) whose 'fortifications' include rail-ings shaped as crossbows with quivers full of – tulips? In these and in countless similar but

more abstract examples, Mackintosh takes the idea of fitness or 'seemliness' (a favourite term) to a level of aesthetic expression undreamt of in the philosophies of his contemporaries.

Mackintosh's joblist for Honeyman and Keppie in the years prior to the commission in 1896 for the Glasgow School of Art was very considerable, and if one were to characterize his chief works of this phase – *inter alia* the Glasgow-Herald building (1893) with its extraordinary, romantic tower and early Art Nouveau carved embellishments; Queen Margaret's Medical College (1894–95) visualized in the beautiful perspective drawing as a medieval nunnery surrounded by its own glebe; and the medievalizing of Queen's Cross Church (designed 1896) – one would qualify them as subjective, emotional rather than rational, and even romantic. As Billcliffe has pointed out, these are characteristics shared with his graphic work in the same period. After 1896 and until the start in 1907 of the second stage of the Glasgow School of Art, which was to become his built masterpiece (others did not proceed beyond the drawing board, although the Art Lover's House was finally built in Glasgow in 1990), his architectural output is truly phenomenal, but even so the list of projects alone gives only a partial

indication of the scale of his creativity: in David Walker's words,

'One room would cost him more real effort than half a dozen buildings would another man.'

The ten-year period from 1897 to 1907, coinciding with the gestation of the School of Art, encompassed three phases (see page 36). In the early phase decoration was chiefly supplied by structural features or the simple provision of a stencilled mural, as at the Buchanan Street tearoom (1897).

During the middle phase ever more complex enrichments in furniture, glass, enamels and metal works were added – compare the relative austerity of Windyhill (1900) with the complex bedroom and drawing-room schemes for Hill House (1902), and the transitional vernacular elevation treatment of both with the timeless modernity of the Haus eines Kunstfreundes (1901).

Finally, in the third phase, an architectonic manner is typified in the Willow Tearoom of 1904, with its endless spatial interplay and elaborate plaster frieze abstractly symbolizing the willow theme. This third phase culminated of course in the *'overwhelmingly full polyphony of abstract form'* (Pevsner) of the Art School

Library interior, with its *'thrilling'* (Howarth) exterior elevations, begun in 1907 and completed in 1909.

Essentially, Mackintosh's main periods of activity as a painter occur before and after this decade of intensive architectural invention. In the difficult and frustrating years after the School of Art, when his architectural practice dwindled precisely when the completion of masterpieces of the stature of the Cranston tearooms, Hill House, Scotland Street School, and the School of Art itself (to say nothing of the brilliant unrealized designs for a Concert Hall, for Liverpool Cathedral and for the Haus eines Kunstfreundes) had given proof to the world of his outstanding talents as a designer of limitless versatility, Mackintosh turned increasingly again to painting.

Apart from Miss Kate Cranston, the one serious patron to employ Mackintosh after 1909 was W. J. Bassett-Lowke, for whom Derngate was built in Northampton in 1916 with interiors by Mackintosh. Here Mackintosh employed a newly minted language of geometrical decoration and a range of strong colours with which he had already begun to experiment as a painter.

'The Four', with Newbery's encouragement, developed great versatility in the design of

metalwork, enamels, book illustration, furniture and posters, and their work was shown, with that of several other Glasgow designers, at the London Arts and Crafts Society exhibition in 1896 in London, where it was received with vociferous hostility. Only Gleeson White, the editor of *The Studio,* admired the work of 'The Four', and he wrote an important series of articles on them, which received more attention abroad than at home.

'The appearance of this article led to an invitation to Charles Mackintosh and Margaret Macdonald ... to hold a show in Vienna. The consequent exhibition there not only established his place as one of the first modern architects and decorators of the day, but gave new life to a group of brilliant young architects, decorators, sculptors and metal workers, who at once acknowledged him as their leader. The rooms in the Turin International Exhibition of 1902 ... were very rich in the work of 'The Four' (Jessie Newbery, ibid.).

Margaret's collaboration with Mackintosh took the form chiefly of decorative panels for individual pieces of furniture or for specified interiors, where they were of central importance to the whole scheme, in terms both of colour

and content. Writing to Hermann Muthesius in 1900, Mackintosh says:

'. . . *just now we are working at two large panels for the frieze [The May Queen and The Wassail for the Ingram Street Tearoom] ... Miss Margaret Macdonald is doing one and I am doing the other. We are working them together and that makes the work very pleasant. We have set ourselves a very large task as we are slightly modelling and then colouring and setting the jewels of different colours.'*

Here Mackintosh is describing the extraordinary technique visible also in the most celebrated of these panels, that designed by Margaret for the 'Room de Luxe' with its silver-painted furniture and *'inexplicable splendour'* of enamelled and mirrored glass, on the first floor of the Willow Tearoom (based imaginatively on Rossetti's sonnet, 'O ye, all ye that walk in Willowwood'), where string and coloured beads are worked into the modelled and painted gesso.

Pamela Robertson informs us that Margaret provided five panels for furniture designed by her husband, and that her work was included in eleven of his projects. We know from the evidence of his letters how much

he appreciated her and respected her work.
Professionally as well, it was clearly a marriage
made in Heaven. Although Mackintosh's
espousal of the ethereal, Maeterlinckian, fairy-
tale subject matter, which we rightly associate
with Margaret and to a lesser extent Frances
Macdonald, was of short duration and only a
handful of his graphic works can be ascribed
to it – *Part Seen, Imagined Part* (1896: GAG)
and *In Fairyland* (1897: private collection) are
examples – one wonders whether a master-
piece such as the astonishing bas-relief plaster
frieze for the Willow Tearoom (1904) would
have been within his grasp had it not been for
the encouragement of Margaret's interest in
modelled gesso reliefs.

Much ink has flowed on the difficult ques-
tion of who among 'The Four' was the first to
arrive at the new style. The available evidence
may be inconclusive on this point, but it is
extremely impressive as regards the origi-
nality of 'The Four' themselves. Well might
the Macdonald sisters have teased the earnest
Gleeson White who was questioning them on
the sources of their style with the answer 'We
have no basis'.

Very early drawings, such as Mackintosh's
design for the Diploma of the Glasgow School of
Art Club (1893: Howarth collection), perhaps

Mackintosh's immediate response to Jan Toorop's *The Three Brides*, or his *Conversazione* programme for the Glasgow Architectural Association (1894: ibid.), or Margaret's invitation card for a Glasgow School of Art Club 'At Home' (probably 1893: HAG), or the sisters' work for an illuminated manuscript within beaten metal covers, *The Christmas Story,* which includes very early work by Margaret and Frances (1895–96: ibid.), reveal such confident individuality that the truth is that these artists probably arrived independently at similar conclusions at the same time.

Interestingly, the two invitation cards by Mackintosh and Margaret share an important and unusual compositional device, which seems to be based on a section cut through an apple or a pomegranate, formed in Mackintosh's case by a flight of birds and in Margaret's by the wings of an angel. This is an early hint of much that is to come in Mackintosh's vocabulary of ornament, just as his Diploma design is a distant forerunner of the Willow plaster frieze of *c.*1904.

However, David Walker has reminded us, in the interior of the hall of Glasgow Art Club (and, he might have added, in the carved decorations to Craigie Hall in the same year) were details

'whose strange attenuated figures and elongated S-stems with balloon flowers and friezes of sinister whorls of thistles anticipate any mature work of this type by the Macdonalds so far discovered.'

From the beginning Mackintosh's work as a watercolourist and draughtsman appears calmer and less eccentric or eerie than that of his three colleagues. *The Harvest Moon* (GSA), his wonderfully assured, poetic watercolour of 1892, is a transitional work. It is his earliest masterpiece in this medium, which was favoured by 'The Four' and their contemporaries to the virtual exclusion of the more material, denser oil medium. Here, the subject itself is reminiscent of the crepuscular mysticism of the Kirkcudbright artists of the later Glasgow School, particularly Hornel and Henry, while the classically draped recumbent female figure personifying a cloud distantly echoes the Aesthetic Movement. But the angel whose wings ring the moon, with her elongated limbs, tiny extremities and S-curve drapes, clearly anticipates the new style, while the beautifully articulated thorn branches in the foreground, so strangely and vividly alive with their autumn berries and quinces, seem as vitally engaged in the mysterious drama of dusk as the personified

moon and cloud. *The Harvest Moon,* related in its atmosphere of mystery to some of the work of the Glasgow School painters, like *The Descent of Night* in *The Magazine,* April 1894, using the female figure as a symbol, fascinates the viewer, irrespective of the subject, by the brilliant solution to the technical problem of a stencil-like separation of areas of paint from each other. This technique was also adopted in the extraordinary *The Shadow* (1895–96: *The Magazine,* Spring 1896), an exquisite wash drawing in three colours of a plant form like a thistle but equally resembling one of Mackintosh's own wrought-metal finials, with its shadow drawn isometrically. On the other hand, Mackintosh was occasionally as ready as his three colleagues to be deliberately obscure, although he rebuts this charge with amusing disingenuousness in the justly celebrated text which accompanies his watercolour *Cabbages in an Orchard* which appears in *The Magazine* of April 1894. The watercolour anticipates Klee; the text is equally original. Mackintosh seems only once to have reverted to this mode of watercolour painting in the later marvellous and mysterious *At the Edge of the Wood* (*c.*1905) .

Two watercolour drawings, both from *The Magazine,* are perhaps Mackintosh's greatest works in the medium. The long titles with

which they are inscribed *recto* by the artist are indispensable pointers to their meaning, the alleged impenetrability of which is in danger of becoming a hallowed tradition among Mackintosh commentators. In fact, their meaning is clearly revealed by a close study of what they actually represent and would immediately have been recognized by the close circle of students among whom *The Magazine* was circulated.

The Tree of Personal Effort, whose healthy roots are visible, thrives in the hostile climate of a freezing sky and arctic sun – *The Sun of Indifference* – wonderfully suggested by subtle washes of slate and emerald. Its leaves and blooms, though little, are healthy, well ordered and beautiful in colour. (In the famous lecture on 'Seemliness' in 1902 Mackintosh will write, *'Art is the flower – Life is the green leaf.'*) But the 'personal effort' and 'indifference' of the title are anthropomorphic and can only refer to the artist and his public. The symbolism is clear: the artist will create and thrive, through his own efforts, in a climate of indifference. Whereas, in the companion watercolour, the baneful glare of *The Sun of Cowardice* produces in *The Tree of Influence, the Tree of Importance,* which is rootless, a crop of imposingly large fruit which however tend to break their own

branches, together with sinister flowers as large as flags joined to a strange vegetable form shaped like a *cuirasse esthetique,* or classical breastplate, a familiar prop of the antique class of contemporary art education, and the 'influence' referred to in the title. Here we have a portrait of the very soul of the artist in travail, personified by the tiny, shrinking female figure of the tree itself, whose artistic growth is stunted by a 'cowardly' dependence on past influences and material reward.

The thought expressed by these two works is repeated in the paper on 'Seemliness' of 1902:

'you must be independent, independent, independent ... Shake off all the props – the props tradition and authority offer you – and go alone – crawl – stumble – stagger – but go alone ... The props of art are on the one hand – the slavish imitation of old work – no matter what date and from what country – and on the other hand the absurd and false idea – that there can be any living emotion expressed in work scientifically proportioned according to ancient principals [sic] *– but clothed in the thin fantasy of the author's own fancy. The artist's motto should be, "I care not the least for theories for this or that dogma so far as the practice of art is concerned – but take my stand on what I myself consider my personal ideal."'*

28. Charles Rennie Mackintosh, *The Tree of Personal Effort, The Sun of Indifference,* The Glasgow School of Art Archives and Collections

If Mackintosh's work is the least florid and the least convoluted of all that was produced by the main exponents of the 'new art', that of the other three members of 'The Four' seems to deserve better the soubriquet of 'Spook School' which came to be applied to their

work in Glasgow. Frances Macdonald's *A Pond* (1894: GSA), included in *The Magazine* for November 1894, shows two emaciated and pallid figures beneath the waters of a pond gently lapped by weed-like growths with heads like tadpoles. Her *Ill Omen* (1893: HAG), also called *Girl in the East Wind*, shows a girl standing with hair streaming in the wind with a flight of ravens – an ill omen – passing the moon behind her; a disturbing, forceful and haunting image of raw originality which must have been very striking in *The Yellow Book,* where it was published in 1896. In the same July issue of this quarterly literary periodical (published in London and whose first art editor was Aubrey Beardsley), another work by Frances and two each by Herbert MacNair and by Margaret Macdonald were also published.) Margaret Macdonald's *Summer* (*c.*1894: HAG), which appears to have been a design for stained glass, shows a man of ancient Egyptian appearance identified with the sun kissing an immensely elongated pale girl who perhaps symbolizes the organic life of the earth. The pair are nude; three years later, in the watercolour *Summer* (GAG), also by Margaret, we find a virtual replica of the earlier composition, but greatly prettified – and it *is* a very pretty work – by the replacement of the

grotesque man with a group of cherubs who symbolize the fertility of the warm season, and above all by the fact that the Junoesque figure of summer herself, now no longer etiolated and sun- or sex-starved, is clothed in a floral gown. The contrast between the two versions illustrates clearly the sisters' tendency at this point to move towards subject matter of ever more feminine whimsicality. This is noticeable in the companion watercolours *Spring* (1897) and *Autumn* (1898) by Frances and *Winter* (1898: all GAG) by Margaret. In each case also the extreme attenuations of drawing have virtually disappeared; Frances's treatment of the female nude is frankly and surprisingly sensual. Her large delicate watercolour *Ophelia* (private collection) in the following year, with its ubiquitous butterflies, harebells and flowing draperies, resembles the work of Katherine Cameron (who contributed an amusing article on butterfly collecting to *The Magazine)* and Jessie M. King.

From 1896 the Macdonald sisters occupied a studio at 128 Hope Street, Glasgow, where painting was only a small part of their remarkable output in various applied media; in 1899 Frances married Herbert MacNair and left Glasgow for Liverpool, where he had been appointed instructor in design; and by 1899

Margaret had begun her long and immensely important collaboration with Mackintosh, whom she married in 1900, as contributor to several of his decorative schemes. After 1900 her work retains the perfumed melancholy of the 1890s to a greater extent than that of Frances, although both sisters in different ways remain equally wedded to the formal vocabulary of that era. Margaret's *The Mysterious Garden* (1911: private collection), for which Billcliffe convincingly suggests a source in Maeterlinck's story *The Seven Princesses,* relates to the Mackintoshes' scheme for the Waerndoerfer Music Salon in Vienna and employs a suitably Klimt-like decorative frieze of masks; while the almost monochromatic *The Pool of Silence* (1913: private collection) transforms the Ophelia-like subject in a near-abstract treatment which also has the sculptural quality of one of her own gesso reliefs.

It is a strange fact that after Frances's return to Glasgow with her husband in 1908, after nearly a decade of disappointed ambitions and dashed hopes, she and Margaret never resumed their former collaboration. After her return, Frances produced two moving watercolours that technically may suggest an unpractised hand but actually demonstrate that the Art Nouveau style of 'The Four' was still capable of poignant, painful

expressiveness. The eternal triangle is the theme of *The Choice* and *'Tis a long Path which wanders to Desire* (both *c*. 1909–15: HAG); gone indeed, in the cold light of the new century, are the care-free fancies of the artist's young womanhood. The sequel is sadder still: Frances died in 1921; her husband lost all interest in art and destroyed the bulk of her work. As a response, surely, to the death of her sister, Margaret painted the beautiful *La Mort Parfumée* (1921: private collection).

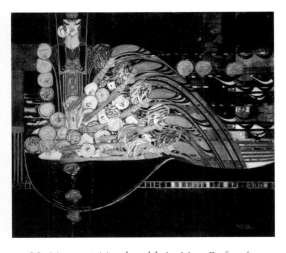

29. Margaret Macdonald, *La Mort Parfumée,*
© Hunterian Museum and Art Gallery, University of Glasgow

In this painting five mourning figures (possibly a single figure viewed episodically in a stooping forward movement) place roses on a bier, above which the soul of the departed rises serenely.

As Art Nouveau is essentially a linear rather than a painterly style, and broad handling of paint is strongly characteristic of all Glasgow School painting, there is little of the Art Nouveau style *per se* even in the later paintings of the Glasgow group who were its immediate forerunners. However, as mentioned above, an exception is provided by the early work of David Gauld (1865–1936), who was one of the younger members of the group. Gauld was a friend of Mackintosh, who in 1893 gave Gauld a set of bedroom furniture as a wedding present. Gauld's *St Agnes* of 1889 (NGS), inspired perhaps by Keats's poem or the Christmas carol 'Good King Wenceslas' which had in 1887 provided Roche with the theme for his most successful picture, and depicting the village of Cambuskenneth on the Forth in the background, is pervaded with *fin de siècle* feeling – more than ten years before the end of the century. The Stevenson *Notes* describe Gauld in glowing terms: '*The youngest of them all … his work simply burns with spiritual power.*'

A smaller work, *Music* (1889: HAG) is very

similar in style and contains the same ingredi-
ents as the *St Agnes* picture: a form of cloison-
nism which makes both pictures look as if they
had been conceived as stained glass; a division
of the landscape background into parallel bands
of colour; and the foreground figures (*'dressed
in the aesthetic garb of the 1890s with a hint of
Japanese influence'*) symbolizing the presence
of saints and angels on the earth with which
they blend so harmoniously. The static deco-
rative style of Burne-Jones is a distant influ-
ence on *St Agnes*, and this is also evident in the
stained-glass designs which Gauld produced
for Guthrie and Wells from about 1891,
which include a lyrical three-window triptych
installed at Montgomerie Quadrant, based on
Music. Perhaps *St Agnes* was similarly realized in
stained glass.

In one of the most curious of these designs
– Gauld's stained-glass windows for the proto-
Art Nouveau house Rosehaugh (*c.*1893) on
the Black Isle – a free adaption was made of
the composition of *The Druids* by Henry
and Hornel. Gauld's largest commission as
a designer of stained glass was for a series
of windows for the Scottish Church of St
Andrew in Buenos Aires, made and assem-
bled by Guthrie and Wells over most of the
decade before 1910. This work seems to have

preoccupied Gauld virtually to the exclusion of all else during that time. Partly as a result, Gauld's work as an innovative painter ceased, and he became well known and widely collected in Scotland as a painter of calves in landscape. Two little early landscapes at Sorn, and *Homeward* (*c.*1891: private collection), which Elizabeth Bird has shown to derive from Matthew Maris, indicate Gauld's return to a more conventional style; one ought to add that repetitious though this became, Gauld's painterly touch never seems to have deserted him. He did paint a delightful *Head of a Girl* (*c.*1893) with the head showing the influence of Bastien-Lepage surrounded by boldly painted foliage, painted at about the time of his marriage and perhaps his own epithalamium, and a few watercolours in a similar style have appeared in the salerooms. Few artists base a secure place in the history of the Glasgow School on such a tiny handful of pictures.

Sir D. Y. Cameron (1865–1945), who remained on the periphery of the Glasgow School, and his sister Kate Cameron (1874–1965) contributed to *The Yellow Book*, making a rare link with London aestheticism but looking a little out of their depth. D. Y. Cameron's *The White Butterfly* (*c.*1892: FAS), influenced by

Matthew Maris, has a decorative emphasis rare in his work, which tends to severity, a quality shared with the more dramatic James Pryde, with whom Cameron had trained at the Trustees' Academy in Edinburgh. Pryde, as one half (with William Nicholson) of the 'Beggarstaff Brothers', as they called themselves, made an important contribution to illustration and poster design in the 1890s. His career was entirely spent in London.

CHAPTER 9

Significant Others

THE BEGGARSTAFF BROTHERS' collaboration lasted from 1894 to 1896 and although the easily printed, flattened outline style of their lithographs became fashionable and produced some of the most characteristic images of London in the 1890s, it did not earn much for the two young artists, Pryde and Nicholson. James Pryde (1866–1941), after study at the Trustees' Academy, moved permanently to London in 1890, following his sister Mabel who, at the age of seventeen, had run off to study painting in the metropolis, where she was to meet and marry William Nicholson. Pryde's memories of Edinburgh, which he called 'the most romantic city in the world', were to inform his painting: the formal grandeur of the New Town; the monumental architecture of the Old Town; the romance of Holyroodhouse with its great bed of Mary, Queen of Scots, which inspired a series of twelve paintings. As he said, '*A bed is an important idea. Look what happens on it and how much time we spend on it*'. The similarities

between the early work of Pryde and D. Y. Cameron are obvious, and must stem from their common training. Both display an interest in rather austere architectural subject matter that is in each case matched by a restrained use of colour – sepia, ochre, burnt sienna.

But an influence other than Edinburgh's imposing buildings operated from the beginning on Pryde. His parents were great lovers of the theatre and included Henry Irving and Ellen Terry among their friends. Ellen Terry's son Edward Gordon Craig became a close friend of Pryde in London and even put several small touring parts his way when his income from painting was insufficient for basic requirements. There is a good deal of common ground between Craig's dramatic designs for theatre sets, with their sense of scale and chiaroscuro, and Pryde's style as a painter. *The Unknown Corner* (1912: Fleming Collection) is reminiscent of Edinburgh's Cowgate with its huge subterranean arches, while the little figures dwarfed by the great wall behind them are simultaneously a memory of the strolling players and human flotsam of Edinburgh's Old Town, and of the seventeenth century mannerist figures which inhabit the etchings of Bellange and Callot. In this typical work there is indeed a strong sense of the theatre, of the way in which the players

are dwarfed by the vast height of the backdrop, and also of the intensely dramatic, artificial quality of stage lighting.

Perhaps no twentieth century artist before Utrillo could invest a blank wall with as much significance as Pryde. *The House* (1914) presents a single architectural elevation without depth, exactly like a stage flat; but the windows which penetrate this surface hint at a mysterious interior with glimpses of figures and drapes. The surface of the wall is weathered; the building possesses a mysterious life and is somehow animated, just as the sky beyond is also dramatically alive, each rendered by a painterly, scumbled technique. The artist's horror at the destruction of war is conveyed most powerfully in *The Monument* (1916–17: GAC). Before a desolate landscape under a lowering sky, a huge statue in a shattered architectural niche appears to bleed. Pryde's dramatic qualities as an artist attracted the patronage of Lady Cowdray, who commissioned twelve large works for the Library at Dunecht; other commissions followed, including several for portraits – his sitters included Lady Ottoline Morrell and his parents' friends Ellen Terry and Henry Irving – and a period of success and acclaim from about 1905 until 1925 preceded a sad final period of decline and neglect. An exhibition at the

Redfern Gallery in 1988 did much to recall this important artist to our attention.

Like James Pryde, James Watterston Herald (1859–1914) studied at Herkomer's school at Bushey (he enrolled in 1891) where Pryde's work impressed him and is perhaps behind the sophisticated placement on the page which characterizes Herald as a composer. A tiny watercolour, *Femme assise au Café* (FAS), could indeed have come straight from the pages of *La Revue blanche*, although no connection can be demonstrated between Herald and Paris beyond his admiration for the Beggarstaff Brothers' French-inspired work. As already noted, the no-less modernistic style of Arthur Melville, who like Herald was native to Angus in the east of Scotland and of whose work he would have been well aware if only from the Glasgow International Exhibition which Herald visited in 1888, was equally a determining influence in his style as a watercolourist. For Herald was a true artist, brilliantly gifted as a draughtsman and the most poetic watercolourist of his day. He was keenly interested in the new style of the 1890s despite his voluntary rustication after 1901 in the old and historic burgh of Forfar where his roots were, where he felt comfortable with his drinking cronies or among his musical friends for whom he played the violin and who

bought his watercolours, and where a drawing was acceptable tender for many a bill.

Although David Gauld's, George Henry's and E A. Hornel's work of the 1890s betrays many of the characteristics of the new art, they are part of the history of the Glasgow School, while in the same city J. Q. Pringle, quintessentially a painter of the nineties, is no less part of Glasgow's *fin de siècle* efflorescence. It may smack of truism to say that Bessie MacNicol, like Pringle, was not one of the Glasgow Boys; but as the most accomplished of a remarkable group of women artists who in those separatist days exhibited under the auspices of the Glasgow Lady Artists' Club at their elegant premises in Blythswood Square, where her contemporaries included the painter Stansmore Dean and the illustrators Olive Carlton Smyth, De Courcey Lewthwaite Dewar, Annie French and Jessie King, Bessie MacNicol seems to belong with a small and select group of Scottish artists whose intimist, tender and reflective style as easel painters working in oils stamps them as children of the nineties.

Other names that immediately occur in this context are W. J. Yule (1869–1900), who was a contemporary of George Dutch Davidson and John Duncan in the Dundee Graphic Arts Association, and studied under Professor Fred

Brown at the Westminster School before being taught by J-P. Laurens in Paris; Robert Brough (1872–1905), who came from Aberdeen and studied under Laurens and Constant in Paris; and Beatrice How (1867–1932), who seems to have attended the Herkomer School at Bushey at the same time as Herald and the Beggarstaffs, and was then trained at the Académie Delecluse in Paris, where she lived in the same street as J. D. Fergusson, rue Notre-Dame-des-Champs.

Bessie MacNicol's work is rather rare and infrequently dated. There seem to have been three main phases in her style: a tonal manner using a dark palette deployed in vivacious portrait studies (e.g. *A French Girl*) often in semi-profile or *profil perdu*; a more open manner employing a lighter palette in *maternités* of great intimacy and delicacy which inevitably recall Berthe Morisot or Mary Cassatt, of whose work she was surely aware; and what one might term a Kirkcudbright style exemplified in her painterly portrait of Hornel.

The work of Beatrice How, exemplarily revived by the Fine Art Society in 1979, is more delicate still. The absence of dates makes a chronology difficult, but again we are in the presence of an artist of impressively consistent quality whose subtle intimacy in studies of mothers and babies and in portraiture makes her a worthy

contemporary of the Nabis and above all of her friend Albert Besnard.

Robert Brough and William Yule share an east coast background and a Paris training – and the special qualities of delicacy, intimacy and tenderness which mark them out as paragons of the nineties. The present state of knowledge of both artists is again scanty. Yule is best documented in Messrs Geering and Colyer's sale catalogue of 22 September 1982, where his brilliancy with the pencil in a style very close to that of Herald, and his incisiveness as a portraitist are much in evidence. Brough we know to have specialized in portraiture after his return from Paris in 1897, when he spent three years in Aberdeen before removing to London where he become Sargent's neighbour and friend and enjoyed tremendous success, Sir James Caw tells us, until his premature death – the norm for this little constellation of artists – in a train crash in 1905.

Some of the key Glasgow School painters became members of the New English Art Club on or shortly after its foundation in 1886. Lavery and Alexander Mann were founder members and J. E. Christie (a Paisley artist who moved to London in 1885), Guthrie, Henry, W. Y. MacGregor, Paterson, Roche, Crawhall and Walton together with two other Scottish artists,

J. Cadenhead and Maurice Greiffenhagen, became members or sent pictures in the years immediately following. By then the Scottish contingent were fully fledged exponents of the new Realism and would have little to learn from their English contemporaries, but recognition in the metropolis was, as ever, important, and Henry, Lavery and Walton, like Melville, were soon to pursue their careers in London.

The Glasgow School's representation at the New English Art Club was at its most numerous in 1890, but they had resigned almost as a body in 1892 due to what they saw as a political rejection of a Scottish picture by the London Impressionist group who were attempting to dominate the Club. The Scots must have felt encouraged by the reception accorded to their exhibition at the Grosvenor Gallery in the summer of 1890, to which the most important of these artists, with the addition of Thomas Millie Dow, William Kennedy, Thomas Corsan Morton, and George Pirie, sent some of their strongest works. This exposure in London and the resulting *succès d'estime et de scandale* led directly to the invitation from Herr Firle and Herr Paulus to exhibit with the Munich Secession at the Glaspalast later that same year, which was the beginning of international recognition and the first of many exhibitions

and sales abroad, both in Europe and in North America. The critic of the *Muenchener neueste Nachrichten*, Fritz von Ostini, wrote in unequivocal terms of admiration,

'*a Glasgow School really does exist! It is not merely that a score or so of painters have established their studios in Glasgow and now happen all to paint good pictures. They form an organic whole, heterogeneous as they may be; they are united by one aim, one spirit, one power, they all spring from the same soil. This spontaneous growth of a school of painters of such importance is perhaps without parallel in the history of art ...*'

and at the same time he used the word 'school' by which we still refer to the Glasgow painters.

The culmination of this activity was reached in the last years of the nineteenth century and the first decades of the twentieth with the dealing of Alexander Reid (1854–1928) and with the formation of Sir William Burrell's vast collections. Reid's Glasgow firm La Société des Beaux-Arts was started in 1889. Reid supported the young Glasgow painters from the early eighties, and until 1892, when he held his first exhibition to include French Impressionist paintings in Glasgow, he seems to have concentrated on the Barbizon painters and the Hague School.

He was on friendly terms with Fantin-Latour and showed him in Glasgow first in 1897. Reid knew Van Gogh, with whom he shared lodgings in 1886 in Paris and who painted his portrait (GAG). A note by Mrs S. J. Peploe (Peploe MSS) mentions that Reid also knew Gauguin, but Reid did not buy examples of his work until well after 1900.

Although not one of the Glasgow group – he never took part in their exhibitions and was only an artist in the time he could spare from his practice as an optician – John Quinton Pringle (1864–1925) was in some ways the most gifted of all his contemporaries in Glasgow, indeed in Scotland. His associations are entirely with Glasgow, where he was born. He studied at the Glasgow School of Art's evening and early-morning classes from 1885 to 1895 and from 1899 to 1900, all the while uninterruptedly pursuing his daytime profession of practising optician at his shop in the Saltmarket near Glasgow Cross where the television pioneer James Logie Baird and the playwright James Bridie were among his clients. Technically his work possesses a degree of refinement unique in the Scottish and indeed in the British context of the day. He was thus a most thoroughly trained artist but never a professional in the financial sense and to this independence and the

consequent lack of temptation to over-produce can be attributed the smallness of his output, his extreme consistency of quality and his individuality of style.

It is an astonishing fact that he seems to have had very little contact with the Glasgow School artists who were constantly in the local news; his artistic mentor and encourager was Fra Newbery, the far-sighted head of the Art School, and there exists a fascinating photograph which shows him in the company of his contemporary at Glasgow School of Art, Charles Rennie Mackintosh, at Gladsmuir, William Davidson's house at Kilmacolm. He created works of consistent quality that can be both dreamily poetic and painstakingly observant. In his choice of subject-matter, however, he departs little from his precursors of the Glasgow School.

Pringle's earlier pictures exhibit the most fastidious and detailed realism allied to the minute execution and it is not surprising that he later painted a number of portrait miniatures on ivory (of which Sir James Guthrie possessed two examples). Two early portraits in oils, of himself and his brother Christopher Pringle, *Artist with Palette* (*c.*1886: GAG) and *Portrait of the Artist's Elder Brother* (*c.*1890: TG), are painted with relative freedom and are sensitive studies of

their subjects reminiscent of E. A. Walton's early watercolours. From the same period date several delicate and subtle views of Glasgow back-court scenes – *Old Houses, Bridgeton* (1890), *Back Court with Figures* (1890: private collection), *Old Houses, Parkhead, Glasgow* (1893: private collection) – the last-named having a special meaning for the artist as his mother was born in one of the houses, and died in it in the year the picture was painted. The culmination of this group is the remarkable *Muslin Street, Bridgeton* (1895–96: ECAC).

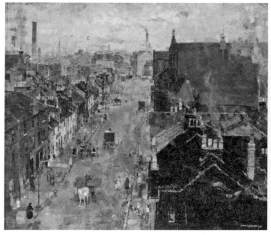

30. John Quinton Pringle, *Muslin Street, Bridgeton,*City Art Centre:City of Edinburgh Museums and Galleries

The artist's own favourite painting, he commented,

'There will never be another Muslin Street – quite apart from the skill no-one could afford to spend the time on it.'

Yet despite its minuteness of execution, the painting has a fresh immediacy and a sense of scale which belie its small size.

Here too, Glasgow School precedents exist in the Glasgow Street scenes painted a little earlier by James Nairn – *West Regent Street* (1884) – and Thomas Corsan Morton – *St Vincent Street* (1887: private collection) – which both adopt the high viewpoint also employed by Pringle. Pringle here uses a noticeably tonal palette with infinite variations on a narrow range of blue-grey enlivened only by the inclusion of passages of rust-red. A similarly restricted palette is visible in another realist *tour de force, The Loom* (1891: ECAC), a composition of immense spatial complexity with every detail sharply articulated yet retaining a sense of air and atmosphere, each surface painted with infinite variations of brushstroke in such a way that it is simultaneously described and illuminated by the light in the room. Meldrum records that this canvas, measuring nine by eleven inches,

took three summer months to complete, during which Pringle devoted two hours to it every morning before setting out for the shop.

In a slightly later group of pictures painted between 1903 and 1908, a more poetic conception of subject-matter is evident – *Girls at Play* (1905: HAG) – and a more open, transparent execution which is intriguingly close to the pointillism of the Neo-Impressionists whose work Pringle is most unlikely to have known at this stage in his career, as Meldrum has emphasized, *pace* Buchanan who claims to see the influence of Le Sidaner.

These works are in fact astonishingly original in technique, the subject-matter emerging through a mesh of tiny brush strokes of colour which form the bejewelled surface of the painting and at the same time suggest the surrounding atmosphere which diffracts the colours perceived within the three dimensions of the picture space. The most consistently divisionist work in his *oeuvre*, probably, is *Tollcross, Glasgow* (1908: HAG), which on examination turns out not to be a pointillist work at all – the paint is applied transparently with a square brush in overlapping layers of pure colour or, to be exact four colours: a dominant primary, blue, with its complementary, orange; and the remaining secondary colours green and lilac,

with white. This phase Pringle referred to as his 'very extreme' style in a letter (Meldrum Trustees). Tantalizingly of this very rare artist, it is known that a Continental dealer bought several canvases from him at around this time, although it was not Pringle's normal practice to dispose of his pictures outside the small circle of his family and friends. Two other important works date from this middle period: *Two Figures and a Fence* (1904: GAG) may be unmatched in Pringle's work for its sheer exquisiteness of technique, although it has an indeterminate, dream-like quality also visible in Pringle's largest canvas, *Poultry Yard, Gartcosh* (1906: SNGMA), which so poetically transforms a prosaic theme.

A visit to Caudebec in Normandy in 1910 (his only excursion abroad; he never realized his ambition to take his paintbrushes to Japan) resulted in four oils which were to be the last in that medium for over a decade. It seems likely that the increasingly onerous demands of the shop on his time, and the discouraging climate of the war years, rendered the relative speed of watercolour attractive to the artist. The most important of these is the delicate landscape *On the River Sainte-Gertrude, Caudebec*, which interestingly once belonged to an early collector of C. R. Mackintosh, David Turnbull, who was a partner in Templeton's carpet factory. *The*

Curing Station at Whalsay (1921: AAG) dates from Pringle's last period and marks a return to oil, after a decade of painting only in watercolour. The legacy of painting in the more fluid medium is visible in the increased transparency and fluidity of *The Curing Station*. The return to oil painting caused Pringle no difficulty and he wrote happily in a letter of this time from Whalsay, where he was staying with his friend Dr Wilson: *'my hand is as light as a feather, no difficulty in what I want ...'*, adding that his new Orkney pictures were *not* of the 'extreme school' – a view with which we would now concur. The pictures painted in Orkney only a year or so before the onset of the artist's final illness, show that Pringle's limpid style had lost nothing with the passing of a decade.

CHAPTER 10

Postscript

AT THE SAME time as international acclaim was being granted the School began to disintegrate. In a postscript dated 1895 to the MS *Notes* written in 1891–92, Macaulay Stevenson describes how the artists gradually separated, owing to marriage, honours and success, which prejudiced the School's *'spiritual force'*, so that:

'a sort of apostolate ... now got broken up into a number of individuals with at most a grouping into twos and twos, with perhaps a third in occasional sympathy.'

Stevenson concludes:

'This fair bud of promise put out by Nature came too early in the still tarrying springtime of human progress and the frosts of the winter from which our civilization has not yet emerged have nipped it.'

Between 1887 and 1892 there appear to have been various attempts to formalize the *de facto* existence of the Glasgow School but rather than unifying the group these appear only to have succeeded in ruffling the feelings of various individuals, and the Glasgow School was a spent force by the later 1890s, although its work continued to be seen in special exhibitions all over Europe and America. On two occasions Diaghilev borrowed Glasgow School pictures for exhibitions in St Petersburg in the late 1890s.

Despite their international fame, the reputation of the Boys declined after 1918 and by the 1950s their paintings had been consigned to the basements of museums. However, from the 1960s onwards (a large exhibition of their work was held in the Kelvingrove Art Gallery in 1968) they have been rediscovered by new generations of art historians and curators who have recognized the artistic contribution they have made.

The significance of the School for subsequent Scottish painting lies in its rejection of academic values and its return to the expressive qualities of colour and the vigorous handling of paint. Its impact on contemporary English painting was negligible, but in Scotland it had

considerable influence not only by loosening the grip of Edinburgh and the RSA on the artistic life of Scotland and enabling Glasgow to be recognized as a centre of artistic excellence, but also through the inspiring and energising effect it had on the next generation of painters, especially J. D. Fergusson, S. J. Peploe, Leslie Hunter and F. C. B. Cadell.

There are many instances of a close connection between the Glasgow Boys' generation and those who followed them. Painterliness and high-key colour are features shared by George Henry's *Barr, Ayrshire* and S. J. Peploe's *Spring, Comrie.*

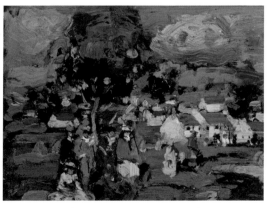

31. George Henry, *Barr, Ayrshire,*
National Gallery of Scotland

32. Samuel J. Peploe, *Spring, Comrie*,
Kirkcaldy Art Gallery,
Fife Council Libraries and Museums

The work of Henry, Hornel, Melville and Guthrie led the Scottish Colourists towards light and colour and the example of the Boys in general provided a template for the independent Scottish painter of integrity. They looked to the wider world, studying in Paris, like many of the Boys, and reserved the right to choose for themselves the path they would take from there. The Glasgow School initiated a Scottish tradition of an emphasis on the handling of paint and colour that persists until the present day.

But then the unexpected happened, as it

will do in the history of style. Glasgow by the 1920s was obsessed by Line. One of the younger members of the group, Sir David Young Cameron, became a leader of a national revival in the technique of etching. Many, if not all, of the Glasgow-trained painters were distinguished printers, and as artists painted in a Linear style. One only has to think of William Strang, Sir James Gunn, William McCance, James McIntosh Patrick, Edward Baird, Robert Sivell, John Laurie, Robert Colquhoun, Robert MacBryde and others, even Joan Eardley.

But that is another story.

APPENDICES

Biographies of the Glasgow Boys

Selected Bibliography

Biographies of the Glasgow Boys

JOSEPH CRAWHALL 1861–1913

Born: Morpeth, Northumberland.

Died: London.

Studied: Paris 1882, Atelier Aimé Morot.

Royal Scottish Society of Painters in Watercolours 1887; International Society 1898; New English Art Club 1909.

Thomas Millie Dow 1848–1919

Born: Dysart, Fife.

Died: St Ives, Cornwall.

Studied: Paris, Beaux Arts, Ateliers Gérôme and Carolus Duran.

Royal Scottish Society of Painters in Watercolours 1885; Glasgow Art Club 1887; New English Art Club 1887.

DAVID GAULD 1865–1936

Born and died: Glasgow.

Studied: Glasgow 1882–1885; Paris 1889.

Glasgow Art Club 1891; International Society 1898; Associate of the Royal Scottish Academy 1918; Royal Scottish Academician 1924.

SIR JAMES GUTHRIE 1859–1930

Born: Greenock.

Died: Rhu, Dunbartonshire.

Studied: Mainly self-taught

Glasgow Art Club 1880 (President 1896–98); Associate of the Royal Scottish Academy 1888; Royal Scottish Academician 1892; New English Art Club 1889; Royal Scottish Society of Painters in Watercolours 1890; Member of the Royal Society of Portrait Painters 1893; International Society 1898; President of the Royal Scottish Academy 1902–19; Society of Scottish Artists 1900; Knighted 1903; Honorary Doctor of Laws (Glasgow) 1906; Honorary Royal Academician 1911; Honorary Doctor of Laws (Edinburgh) 1913; Honorary Doctor of Laws (St Andrews) 1922.

EDWARD ATKINSON HORNEL
1864–1933

Born: Bacchus Marsh, Victoria, Australia.

Died: Kirkcudbright.

Studied: Edinburgh 1880–3; Antwerp 1883–5.

Glasgow Art Club 1886; Honorary Member of
the Society of Scottish Artists 1911; International
Society.

WILLIAM KENNEDY 1859–1918

Born: Glasgow.

Died: Tangier.

Studied: Paisley School of Art (?); Glasgow (?); Paris *c.*1880–5, Bougereau, Fleury, later with Lepage, Collin and Courtois.

Glasgow Art Club 1884.

Sir John Lavery 1856–1941

Born: Belfast.

Died: Kilkenny.

Studied: Glasgow *c.*1874; London 1879, Heatherley's; Paris, Académie Julian.

Glasgow Art Club 1881; New English Art Club 1887; Associate of the Royal Scottish Academy 1892; Member of the Royal Society of Portrait Painters 1893 (later PRP); Royal Scottish Academician 1896; International Society 1898; Associate of the Royal Hibernian Academy 1906; Royal Hibernian Academician 1906; Associate of the Royal Academy 1911; Knighted 1918; Royal Academician 1921; Honorary Doctor of Laws (Belfast) 1935; Honorary Doctor of Laws (Dublin) 1936.

JAMES PITTENDRIGH MACGILLIVRAY
1856–1938

Born: Inverurie.

Died: Edinburgh.

Studied: Edinburgh; Assistant to sculptor William Brodie 1872–78; two years in studio of John Mossman in Glasgow.

Associate of the Royal Scottish Academy 1892; Fellow of the Royal Scottish Academy 1901; Queen's Sculptor in Scotland 1921.

WILLIAM YORK MACGREGOR
1855–1923

Born: Finnart, Dunbartonshire.

Died: Bridge of Allan, Perthshire.

Studied: Glasgow under James Docherty; London, Slade School under Legros.

Glasgow Art Club 1881; Royal Scottish Society of Painters in Watercolours 1885; New English Art Club 1892; Associate of the Royal Scottish Academy 1898; Royal Scottish Academician 1921; Society of Scottish Artists 1900.

ARTHUR MELVILLE 1855–1904

Born: Loanhead of Guthrie, Angus.

Died: Witley, Surrey.

Studied: Edinburgh (evening classes) 1871–8; Paris 1878–80, Académie Julian.

Royal Scottish Society of Painters in Watercolours 1885; Associate of the Royal Scottish Academy 1886; Associate Member of the Royal Society of Painters in Watercolours 1888; Member of the Royal Society of Portrait Painters 1891; International Society 1898; Member of the Royal Society of Painters in Watercolours 1900.

THOMAS CORSAN MORTON 1859–1928

Born: Glasgow.

Died: Kirkcaldy.

Studied: Glasgow School of Art; Slade *c.*1880 for six months; Paris *c.*1880–81.

Glasgow Art Club 1885; Royal Glasgow Institute of Fine Arts; Society of Scottish Artists; Member of the Royal Society of Painters in Watercolours; Keeper of the National Galleries 1908.

JAMES STUART PARK 1862–1933

Born: Kidderminster.

Died: Kilmarnock.

Studied: Glasgow; Paris, Lefebvre, Boulanger, Corman.

Glasgow Art Club 1892; International Society.

JAMES PATERSON 1854–1932

Born: Blantyre.

Died: Edinburgh.

Studied: Glasgow *c.*1871–76; Paris 1877–83, Jacquesson de la Chevreuse, Jean-Paul Laurens.

Glasgow Art Club 1882; Royal Scottish Society of Painters in Watercolours 1885; New English Art Club 1887; Associate of the Royal Scottish Academy 1896; Associate Member of the Royal Society of Painters in Watercolours 1898; Society of Scottish Artists 1899; Member of the Royal Society of Painters in Watercolours 1908; Royal Scottish Academician 1910; Society of Eight 1912; International Society.

ALEXANDER ROCHE 1861–1921

Born: Glasgow.

Died: Slateford, Midlothian.

Studied: Glasgow; Paris, Académie Julian, École des Beaux-Arts.

Glasgow Art Club 1884; New English Art Club 1891; Associate of the Royal Scottish Academy 1893; Member of the Royal Society of Portrait Painters 1898; Royal Scottish Academician 1900; Society of Scottish Artists 1900; International Society.

ROBERT MACAULAY STEVENSON
1854–1952

Born and died: Glasgow.

Studied: Glasgow.

Glasgow Art Club 1886 (President 1898–99);
Royal Scottish Society of Painters in Watercolours
1906; International Society.

EDWARD ARTHUR WALTON
1860–1922

Born: Renfrewshire.

Died: Edinburgh.

Studied: Dusseldorf; Glasgow (perhaps 1878–81).

Glasgow Art Club 1878; Royal Scottish Society of Painters in Watercolours 1885; New English Art Club 1887; Associate of the Royal Scottish Academy 1889; Member of the Royal Society of Portrait Painters 1898; International Society 1898; Royal Scottish Academician 1905; President of the Royal Scottish Society of Painters in Watercolours 1915–22.

Selected Bibliography

William Buchanan and the 19th Century Art Trade in London and Italy, London, 1982

D. Y. Cameron: an illustrated Catalogue of his Etched Work, with Introductory Essay & Descriptive Notes, Frank Rinder. James Maclehose, Glasgow, 1900

Joesph Crawhall. The Man and the Artist, Adrian Bury. Charles Skilton, London, 1958

Sir James Guthrie, Sir James L. Caw. Macmillan, London, 1932

Guthrie and the Scottish Realists, Catalogue by Roger Billcliffe. Fine Art Society, Glasgow, 1981

James Watterston Herald, Catalogue by Roger Billcliffe. Fine Art Society, 1981

J. W. Herald 1859–1914, Kenneth Roberts. Forfar, 1988

'E.A. Hornel Reconsidered', W. R. Hardie. *Scottish Art Review*, new series, XI, 3 & 4,1968

Edward Atkinson Hornel 1864–1932, Catalogue by Roger Billcliffe. Fine Art Society, Glasgow, 1982

Beatrice How 1867–1932 – a Scottish Painter in Paris, Foreword by Arnold Haskell. Fine Art Society, 1979

John Lavery, the Early Career 1880–1895, David Scruton. Crawford Centre for the Arts, St Andrews, 1983

Lavery, W. Shaw Sparrow. Kegan Paul, Trench and Trubner, London, 1911

Sir John Lavery RA, 1856–1941, Introduction by Kenneth McConkey. Ulster Museum & Fine Art Society, London, 1984

The Life of a Painter, Sir John Lavery. Cassell, London, 1940

Alexander Mann 1853–1908, Catalogue by Christopher Newall. Fine Art Society, London, 1983

Alexander Mann 1853–1908, Catalogue by Martin Hopkinson. Fine Art Society, London, 1985

Arthur Melville 1855–1904, Catalogue by Gerald Deslandes. Dundee Art Gallery, 1977

Arthur Melville, Agnes Mackay. Frank Lewis, London, 1951 'Francis Newbery and the Glasgow Style', Isobel Spencer. Apollo, XCVHI, 1973

The Paterson Family. One Hundred Years of Scottish Painting 1877–1977, Ann Paterson Wallace, Belgrave Gallery, London, 1977

James Paterson, Introduction by Ailsa Tanner. Lillie Art Gallery, Milngavie, 1983

John Quinton Pringle, Centenary Exhibition Catalogue by James Meldrum. Glasgow Art Gallery, 1984

John Quinton Pringle, Exhibition Catalogue by David Brown. Scottish Arts Council, Edinburgh, 1981

James Pryde, Derek Hudson. London, 1949

James Pryde 1866–1941, Foreword by John Synge to Exhibition Catalogue, Redfern Gallery, London, 1988

Edward Arthur Walton, Fiona McSporran. Privately printed, Glasgow, 1987

E.A. Walton, Exhibition Catalogue by Helen Weller. Bourne Fine Art, Edinburgh, 1981

The Glasgow School of Painting, David Martin. Blackie, Glasgow, 1897

The Glasgow School of Painters, G. Baldwin Brown. 1908

The Glasgow Boys, Exhibition Catalogue, ed. W, Buchanan. 2 vols., Scottish Arts Council, Edinburgh, 1968 and 1971

The Glasgow School of Painting, Exhibition Catalogue by William Hardie. Fine Art Society, London, 1970

The Glasgow Boys: the Glasgow School of Painting 1875–1895, Roger Billcliffe. John Murray, London, 1985

A Man of Influence: Alexander Reid, Exhibition Catalogue by Ronald Pickvance. Scottish Arts Council, Edinburgh, 1967 'International Glasgow', Elizabeth Bird. *The Connoisseur*, August, 1973

George Buchanan, 'Some Influences on McTaggart and Pringle', *Scottish Art Review*, new series, XV, 2 draws doubtful conclusions from the mass of valuable infomation on the collecting of French pictures in Britain to be found in Douglas Cooper, *The Courtauld Collection*, London University Press, London, 1953.

James Paterson's *Memoir* of W.Y. Macgregor exists in typescript (private collection).

Macaulay Stevenson's ms *Notes* and papers are in the William Hardie Collection, Mitchell Library, Glasgow.

George Dutch Davidson (1879–1901). A Memorial Volume, Dundee Graphic Arts Association, Dundee, 1902

'George Dutch Davidson; The Hills of Dream Revisited', William Hardie. *Scottish Art Review*, new series, XIII, 4, reprinted with checklist of Davidson's work, 1973

Jessie M. King, Exhibition Catalogue. Scottish Arts Council, Edinburgh, 1971

Charles Rennie Mackintosh and the Modern Movement, Thomas Howarth, second edition 1977. Routledge and Kegan Paul, London, 1977

'Charles Rennie Mackintosh: Great Glasgow Pioneer of Modern Architecture' by David Walker, *Glasgow Herald*, 8 June, 1968

Charles Rennie Mackintosh: The Complete Furniture, Furniture Drawings and Interior Designs, Roger Billcliffe, third edition, John Murray, London 1986. This definitive and beautifully produced book supplements the comprehensive bibliography in Howarth with a list of publications on Mackintosh and the Glasgow Style, including Billcliffe's own writings on J.H. MacNair, and *Mackintosh's Architectural Sketches and Flower Drawings* (1977), *Watercolours* (1978), and *Textile Designs* (1982).

Charles Rennie Mackintosh. Margaret Macdonald Mackintosh. The 1933 Memorial Exhibition: a Reconstruction. This reprints Jessie R. Newbery's original Foreword. Fine Art Society, Glasgow 1983.

Mackintosh Flower Drawings, Catalogue by Pamela Robertson. Hunterian Art Gallery, Glasgow, 1988

Remembering Charles Rennie Mackintosh. An illustrated Biography, Alastair Moffat. Colin Baxter, Lanark, 1989

Mackintosh's Masterwork: The Glasgow School of Art, Editor, William Buchanan. Glasgow School of Art, Glasgow, 1989

Charles Rennie Mackintosh. The Architectural Papers, ed. Pamela Robertson. White Cockade in association with Hunterian Art Gallery, Oxford, 1990

Newsletter of the Charles Rennie Mackintosh Society, Glasgow, 1973 et seq.

Margaret Macdonald Mackintosh 1864–1933, Catalogue by Pamela Robertson. Hunterian Art Gallery, Glasgow, 1984

Glasgow Society of Lady Artists, Centenary Exhibition catalogue by Ailsa Tanner. Collins Gallery, Glasgow, 1982

The Glasgow Style 1890–1920, Exhibition Catalogue, Glasgow Art Gallery, 1984

Charles Rennie Mackintosh, Architect and Artist, Robert Macleod. Collins, Glasgow, new edition 1983

Founder Members and Exhibitors 1882–c. 1920 at The Society of Lady Artist's Club, Exhibition Catalogue. Scottish Arts Council, Glasgow, 1968

Glasgow School of Art Embroidery 1894–1920, Catalogue by Fiona C. Macfarlane and Elizabeth F. Arthur. Glasgow Art Gallery, 1980

'Ghouls and Gaspipes; Public Reaction to Early Work of "The Four"', Elizabeth Bird. *Scottish Art Review*, new series, XIV, 4.

Arts and Crafts in Edinburgh 1880–1930, Catalogue by Elizabeth Cumming. Edinburgh, 1985

Sir Patrick Geddes's papers are held by the National Library of Scotland and by the University of Strathclyde

Anne Mackie's Diary describing visits to France in 1892 and 1893 is in the Manuscripts Division of the National Library of Scotland.

The Evergreen: A Northern Seasonal, editor, Patrick Geddes. 4 vols, 1895–1897, Geddes and Colleagues,

Scottish Painting

This book, the third edition of the only book on Scottish painting, will be available in summer 2010.

Illustrated throughout, *Scottish Painting* is by William Hardie. An acknowledged authority on Scottish painting and the author of *The Glasgow Boys in Your Pocket*, he traces the development of Scottish painting from its beginnings in 1753 to the present day.

Press attention for *Scottish Painting*, First Edition:

'No better introductions to painting by Scottish artists has yet appeared, and this book is strongly recommended not only to those who have already looked into this field but also to those to whom Scottish painting is unknown. The style chosen is modest and scholarly, making no extravagant claims for the artists ... It is a pleasure to read work of such quality.'

– John Pinkerton, *Connoisseur*

'... A thorough and scholarly study ...'

– *Arts Review*

And Second Edition:

' ... A literary achievement opening to a larger public the particular richness of the medium in the talented hands of the Scots ... The author is one of the few who could have compiled so discerning a history. This illuminating monograph ... is the best available in its comprehensive survey of two centuries of Scots painting.'

– *Leisure Painting*